VISIONS of PARADISE

Botticini's
Palmieri Altarpiece

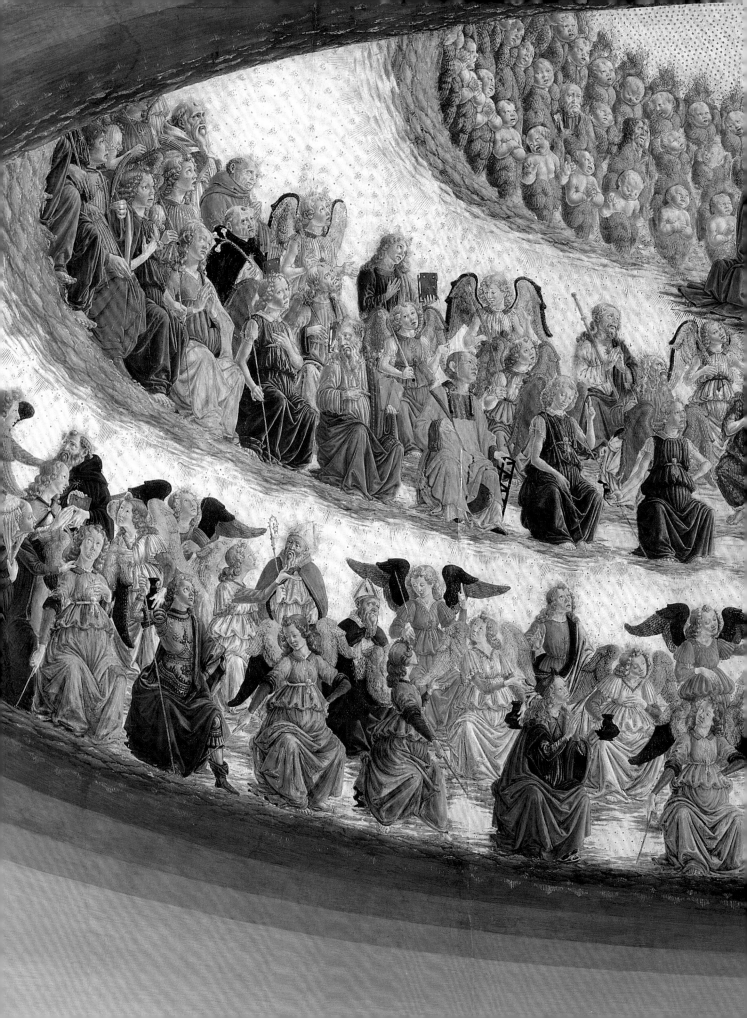

VISIONS of PARADISE

Botticini's Palmieri Altarpiece

Jennifer Sliwka

National Gallery Company
Distributed by Yale University Press

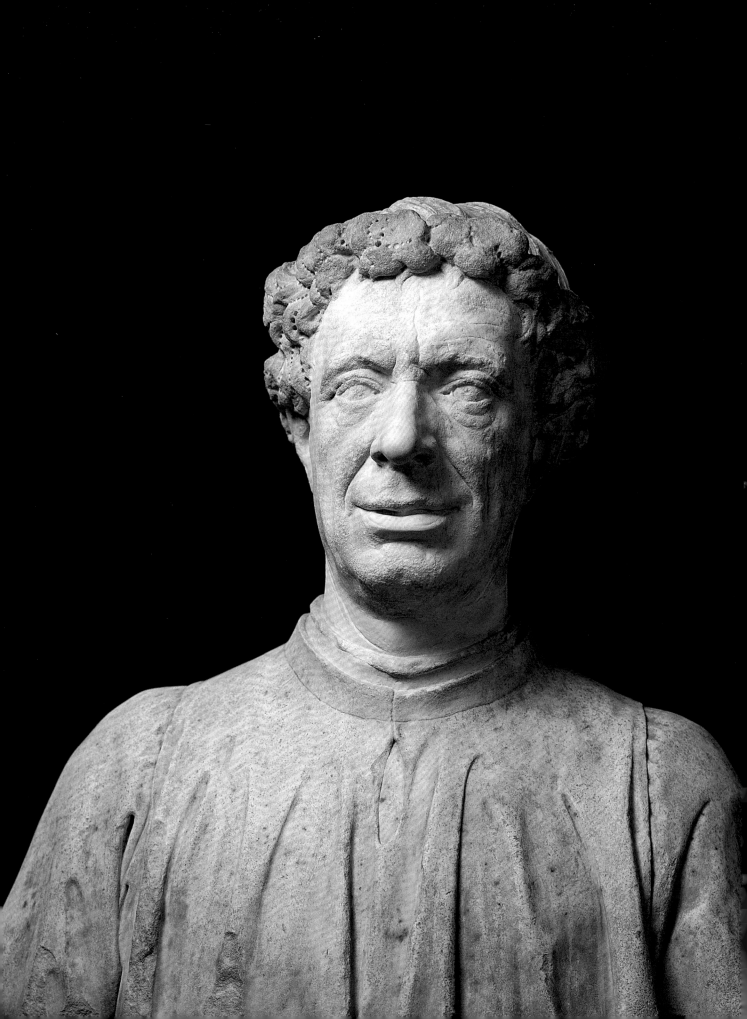

Contents

1

ANTONIO ROSSELLINO
Matteo Palmieri, 1468
Marble, 54 × 60 × 30 cm
Museo Nazionale del Bargello, Florence

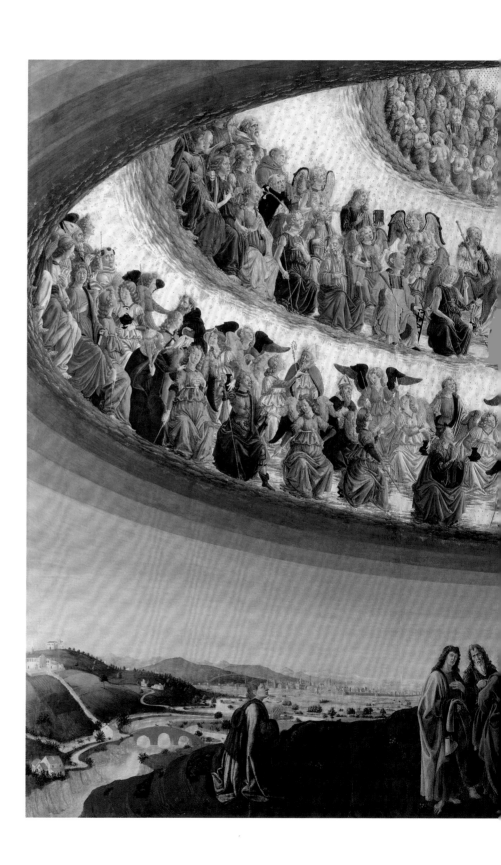

2

FRANCESCO BOTTICINI
The Assumption of the Virgin,
1475–7
Tempera on wood, 228.6 × 377.2 cm
The National Gallery, London

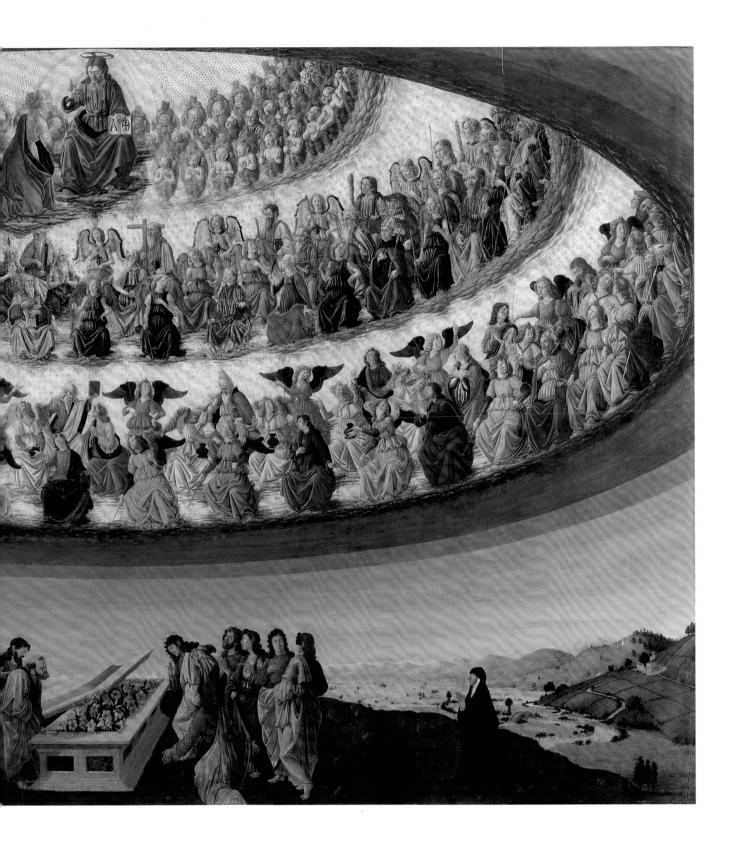

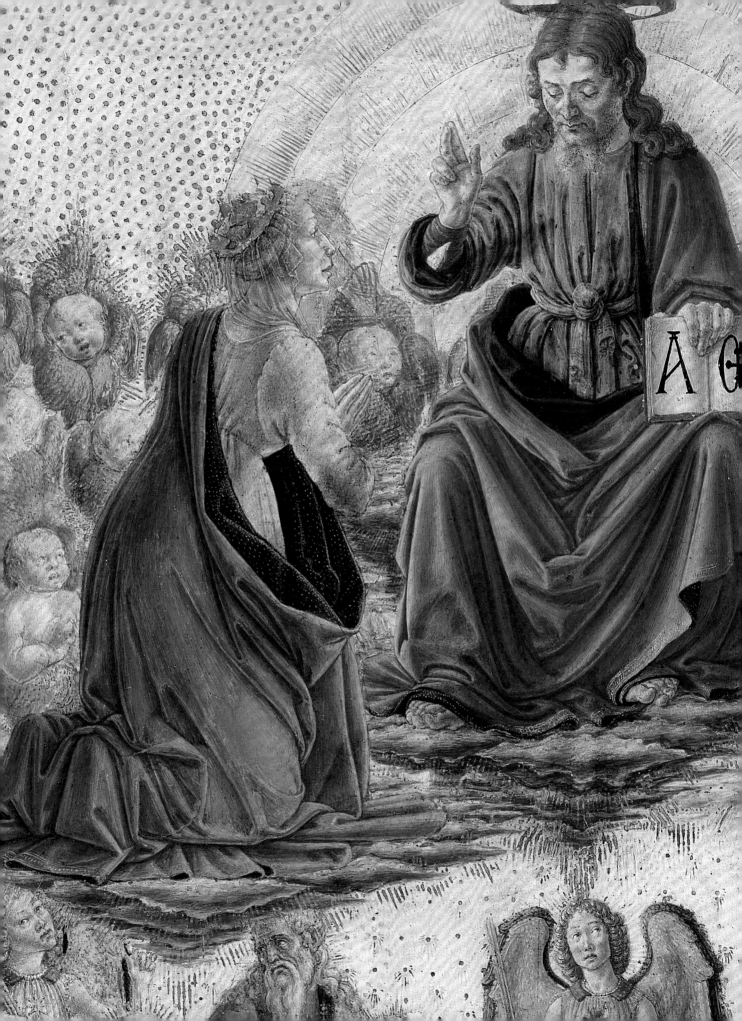

Introduction

This book explores the extraordinary vision of Earthly and Celestial Paradise painted by Francesco Botticini (1446–1497) between 1475–7, probably for the Florentine church of San Pier Maggiore. The painting was originally commissioned by the humanist, statesman, author and poet, Matteo Palmieri (1406–1475) for his funerary chapel, and is now in the collection of the National Gallery, London (fig. 2). The subject of this monumental altarpiece, traditionally described as an Assumption of the Virgin, is more accurately characterised as the Reception of the Virgin into Heaven as she has already ascended and is shown, crowned as the Queen of Heaven, kneeling at Christ's feet (fig. 3). Measuring over two metres high and almost four metres long, this unusually large, horizontal panel depicts the Virgin and Christ at the summit of a dome-like celestial realm, surrounded by a hierarchy of angels, among whom appear saints, Old Testament figures and a sibyl. Below the dome of Heaven, the Apostles are gathered on a hilltop, marvelling at the lily-filled tomb of the Virgin. The painting includes a portrait of Palmieri, kneeling at the left, and of his wife, Niccolosa de' Serragli, to the right, as well as a panoramic view of Florence, represented as a kind of Earthly Paradise, a terrestrial counterpart to the Celestial Paradise depicted above.

Botticini had already worked for Palmieri and knew his long theological poem, the *Città di Vita* (*City of Life*), well, as he had illuminated a deluxe manuscript of it in around 1473 (see fig. 26). Written in 1465, the *Città di Vita* is closely modelled on Dante Alighieri's *La Divina Commedia* (*The Divine Comedy*) of about 1308–20. Like Dante, Palmieri describes his otherworldly journey through the different realms of the afterlife as experienced in a vision.

Botticini's altarpiece has long been considered a kind of visualisation of Palmieri's Dantesque poem, a reading that has led to a great deal of speculation and misinterpretation of the painting that this book aims to redress.

Relatively little is known about Francesco Botticini. We do know that he was born in Florence in 1446 and probably received his first artistic training from his father, Giovanni, a painter of playing cards. At the age of 13, he joined the workshop of the successful Florentine painter Neri di Bicci and, only nine short months later, left the master to work as an independent artist. He appears to have established his own workshop by 1469, and in 1471 he joined the Confraternity of the Archangel Raphael, for whom he painted an altarpiece for the church of Santo Spirito, possibly *The Three Archangels with Tobias,* now in the Galleria degli Uffizi, Florence (see fig. 44). In addition to painting altarpieces, Botticini became a popular painter of works for private devotion and his workshop would become one of the most important in the period for the production of decorative, domestic paintings. Although he worked for some of the most wealthy and prominent Florentine families of the day, including the Strozzi, the Ridolfi (see fig. 52) and the Rucellai (see fig. 62), Botticini's name was largely unfamiliar to art historians until relatively recently. Part of this lack of recognition was because a great many of his works were misattributed to other painters. Giorgio Vasari, the great sixteenth-century painter and biographer of artists, mistakenly praised the Palmieri altarpiece as a masterpiece by Sandro Botticelli when he saw it *in situ* in 1550.

The misattribution of Botticini's works is quite understandable given that his youthful works broadly resemble a number of those of his mid-fifteenth-century contemporaries such as Domenico Veneziano and Alesso Baldovinetti. His works of the 1470s, however, most closely resemble the delicate and graceful paintings of Andrea del Verrocchio (see figs 53 and 56), the dynamic figures and atmospheric landscapes of the Pollaiuolo brothers (see figs 34, 45 and 46) and, increasingly, the elegant figure types, bright colouring and strongly delineated contours so closely associated with Botticelli in this period (see fig. 48).

This book is divided into four chapters, each of which explores a different aspect of the painting in depth. The first examines the extraordinary life, deeds and writings of its patron, a true 'Renaissance man' who excelled as a merchant, politician and scholar. The second chapter takes a closer look at Late Medieval and Renaissance conceptions of the Universe, which located

the Earth, rather than the Sun, at its centre, and imagined Paradise as an earthly garden where the souls would await their ascent, through the celestial spheres, to Heaven. The third chapter sheds new light on the importance of 'place' in the Palmieri altarpiece, demonstrating how the painting's views of Florence and Fiesole represent some of the earliest accurate 'city portraits' in the history of art while also operating on more symbolic or poetic levels. This attention to 'location' extends to the more ethereal or intangible notions of Earthly Paradise and Heaven as represented in the painting. The last chapter focuses on the complicated attributional history of Botticini's *Assumption,* explaining how both its authorship and subject matter came to be misunderstood over the centuries and how over the last century scholars have managed to resurrect Botticini's identity and artistic legacy.

4

FRANCESCO BOTTICINI
Detail from *The Assumption of the Virgin.*

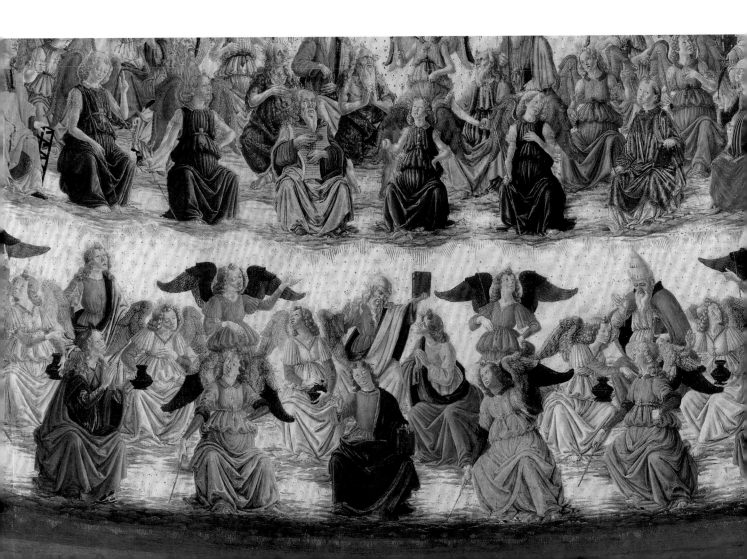

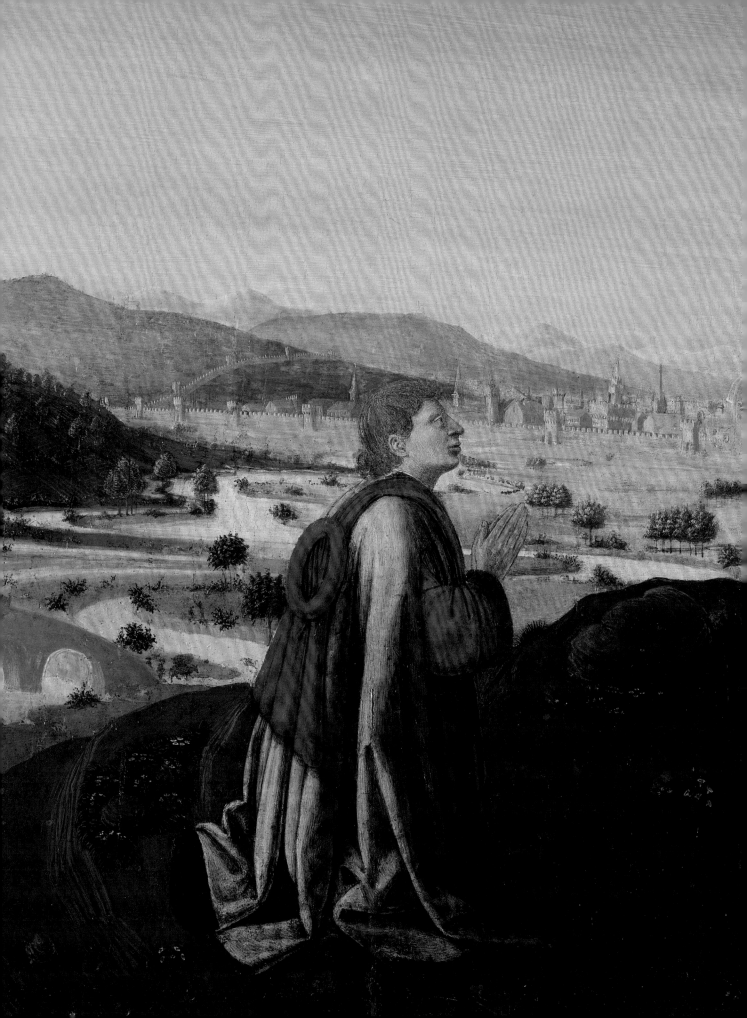

I · Matteo Palmieri: Apothecary, Humanist, Statesman and Patron

Matteo Palmieri (figs 1 and 5), was a 'Renaissance man' in every sense of the term. An apothecary, humanist, statesman and patron of the arts, he was one of the most remarkable Florentines of the fifteenth century. Born into a family of apothecaries, he first trained in the trade but was soon drawn to the heady intellectual circles of scholars, known as civic humanists, who were reading and debating the ancient Greek and Roman writings of Aristotle, Plato, Plutarch and Cicero among others. These scholars were particularly interested in a kind of Classical republicanism, built around concepts of civic virtue and good government, that could serve as a model for their own form of Republican rule. These authors shaped Palmieri's view of civil society, inspiring his treatise entitled *Della Vita Civile* (*On Civic Life*, 1439), historical texts such as the *Liber de Temporibus* (*The Book of Epochs*, 1448) and his epic poem in imitation of the famous Florentine poet Dante, the *Città di Vita* (*City of Life*, 1465).

At the age of 25, Palmieri entered the Florentine government as one of the *Otto Sindaci del Podestà* (Eight Syndics of the *Podestà*). Over the next 44 years he would go on to negotiate eight diplomatic missions for the Republic and take office at least 63 times, achieving the rank of *Gonfaloniere di Giustizia* (Gonfalonier or Standard-bearer of Justice), the city's highest political honour, at the age of 47. The *Gonfaloniere* was the standard-bearer of the Republic of Florence, who was in charge of the internal security forces and the maintenance of public order.

Throughout his political career, however, he maintained his apothecary shop and became a successful merchant, his wealth and influence enabling him to acquire extensive property, to secure and endow a family chapel and to commission sculpture, manuscripts and paintings. This chapter explores Palmieri's life and works to reveal how closely interwoven his varied activities were and how they all served to promote his favoured concept of *utilitas publica,* that is, sacrifice for the common good.

5
FRANCESCO BOTTICINI
Detail from *The Assumption of the Virgin,* showing Matteo Palmieri.

13

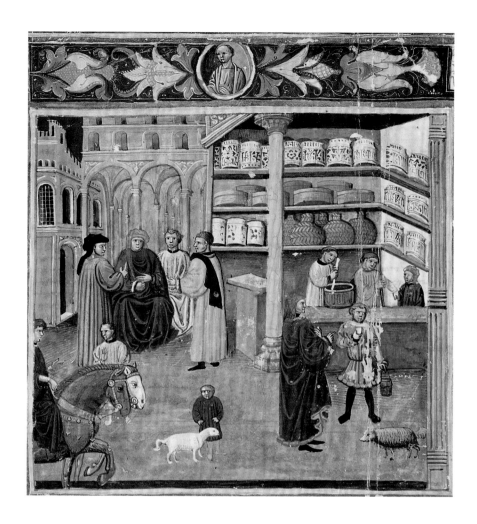

6

Manuscript illumination showing
an apothecary shop from Avicenna's
Canon of Medicine (detail).
Tempera on vellum, about 1440
Biblioteca universitaria, Bologna
(Ms. 2197, fol. 38v)

Palmieri's early life and training as an apothecary

Matteo Palmieri was born in 1406 into a Florentine family of apothecaries
(*speziali*), a profession that specialised in both preparing and selling
medicines and drugs. Palmieri's father, grandfather and two of his uncles
had all matriculated in the Guild of Doctors and Apothecaries (*Arte dei
Medici e Speziali*). In addition to marketing medicine, apothecary shops
sold a range of products including sugar, spices, dyes, wax and painter's
pigments. Selling to everyone from artists to aristocrats, apothecary shops
were particularly social spaces where clients from a variety of social and
economic backgrounds had the opportunity to mingle while they waited
for their medications to be made (fig. 6). It was not only the medicines that
were customised, but also the apothecary jars (*albarelli*) (fig. 7) and other
packaging designed to hold ointments and dry drugs, some even decorated
with the emblem of the shop or the coat of arms of a particular individual.

Apothecary shops played an important role in a series of economic
and social networks in Florence; they were often one of the first ports of
call for travellers, a place to learn the latest news or gossip and to exchange
political ideas. Surprisingly, they were also places to gamble and secure

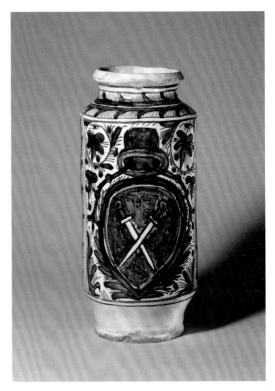

7

Albarello, about 1448–51
Apothecary storage jar.
On one side there is a lion rampant;
on the other, two crossed swords
surmounted by a hat. It was probably
made in Florence for Cardinal Astorgio
Agnese of Naples.
Earthenware, 35.2 × 15 cm
The British Museum, London

informal bank loans.¹ Although apothecaries, as merchants, did not belong to the highest echelons of society, they were often well educated, being numerate as well as literate. In addition, they routinely kept neat journals and account books (a great source being mined by archival scholars today) and actively participated in the city's cultural and political life.

Private life and family business: the apothecary shop at the Canto alle Rondini

In 1428, at the age of 22, Palmieri inherited the family apothecary shop at the Canto alle Rondini in the eastern part of Florence, following the death of his father Marco (fig. 8). Palmieri's older brother Bartolomeo had recently passed away, so the care of both the family business and of Bartolomeo's widow and three small children fell to Matteo. The pharmacy, known as the *bottegha d'arte di spezieria in su Canto alle Rondini*, was located on a corner (*canto*) of the ground floor of Palazzo Uccellini on the Via degli Scarpentieri (now the Via Pietrapiana) and was named after the heraldic coat of arms of the Uccellini family, depicting three swallows (*rondini*) in flight that featured prominently on the palace façade.² Early sources suggest that a pharmacy had existed on this site since the early fourteenth century and it survives to this day (albeit in an altered form) as the Farmacia del Canto alle Rondini (fig. 9).³ Palmieri's house was situated just steps away from his shop, located on the same street, where the family also owned a '*chasolare*', or small lodgings, and a '*chasa ad uso di Fondachetto*', a house used as a warehouse. The Palmieri family's presence in the neighbourhood was marked by their coat of arms on the

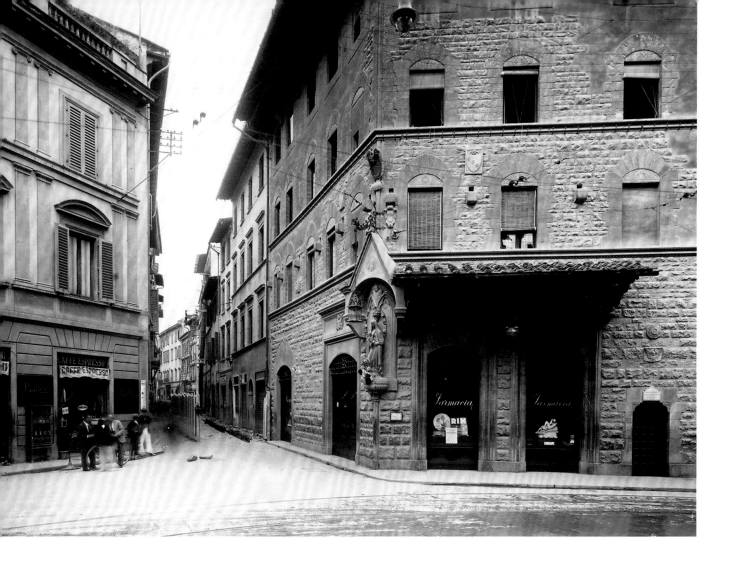

8

1930s photograph of the original location of Matteo Palmieri's apothecary shop. The site is now occupied by the Palazzo delle Poste.

façade of their house (fig. 10) and, later, by a sculpture of Matteo himself (see fig. 1).[4] The family also had close ties with the nearby church of San Pier Maggiore where Palmieri's mother Tommasa, father Marco and uncle Francesco were buried. Although the family did not own the patronal rights to any of the chapels in the church until after Palmieri's death (these were primarily owned by members of the Albizzi family), his father and uncle were buried in the family vault beneath the nuns' choir and his mother was buried just outside the church, presumably in an external wall-tomb, or *avello,* akin to those still visible on the outer walls of the church of Santa Maria Novella in Florence today.[5] Palmieri's wish that he would also eventually be buried in the church is expressed in his will of 1469. Palmieri's *Libro di Ricordi* (a book of family records) also indicates that he made payments to the priests of San Pier Maggiore for wax candles and for masses to be said for the soul of his father.[6] It would have been clear to both Florentines and visitors to the wealthy neighbourhood of San Piero (in and around the church of San Pier Maggiore), that the Palmieri family held a certain prominence in the neighbourhood alongside the more established Albizzi and Alessandri families who owned nearby palaces and the patronal rights to several chapels in the church.[7]

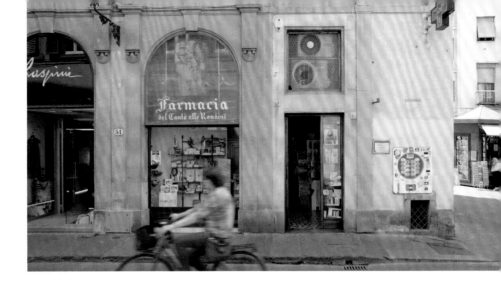

Palmieri's contemporary biographer, Vespasiano da Bisticci (1421–1498), suggests that he was born into a family of modest means.[8] However, tax reports indicate that Matteo's grandfather was in the top 13 per cent of taxpayers in the city in 1403,[9] and tax declarations made by Matteo's father, Marco, indicate that in 1427 the family apothecary shop was valued at a healthy 710.2 florins.[10] While it is difficult to quantify the value of a Florentine florin today, economic historians have surmised that the annual minimum wage in Florence in 1427 was about 14 florins and that this sum remained relatively constant throughout the fifteenth century.[11] A certain Piovano Arlotto, writing in about 1480, indicates for example that a man with a wife and three or four children could live quite comfortably in Florence on an income of around 70 florins.[12] Surviving accounts reveal, however, that higher government officials earned between 100 and 150 florins a year, while a manager in a merchant-banking house could make up to 200 florins, and top lawyers and university professors could earn even more.[13] In 1431, only a few years after Matteo inherited the shop, he managed to more than double its value to 1503 florins, a testament to his business acumen.[14] Further, Palmieri's *catasto* (a public register showing the details of ownership and value of land made for the purpose of taxation) of 1430 and 1433, in which he records the names of those who owe him money, reads as a 'Who's Who' of fifteenth-century Florence. Members of the most politically and socially eminent families in the city, such as the Albizzi, Alessandri and the Tanagli, frequented his shop where they bought goods on account.[15]

In the summer of 1433, Matteo married Niccolosa (also known as Cosa) de' Serragli, daughter of Niccolò, a banker with a distinguished financial and political past (fig. 11).[16] Palmieri records having received two properties from her father as part of her dowry, a little farm in Valdelsa in the parish of San Niccolò, known as 'il Sodo', and a farm called the 'Casa Bianca' situated on the slopes of Marcialla in Valdelsa that he subsequently sold in 1458. Although Matteo and Niccolosa had no children, they raised Matteo's deceased brother's offspring as their own.[17] In addition to his two nephews, Antonio and Agnolo, and his niece Margherita, Matteo also cared for his younger sister, Maddalena, until her marriage in 1435, and for his mother

until her death in 1462. As Palmieri recorded in his *catasto* of 1457, '*abbiamo molte bocche in casa*' (we have a lot of mouths in this house).[18] Matteo's *Ricordi* reveal that, increasingly, he involved his nephews in the family business and that by 1447 he had handed over the day-to-day running of the apothecary shop to Agnolo, the younger of the boys.

In 1451 Matteo acquired a second apothecary shop, located in Florence's Mercato Vecchio, which he put under the care of his other nephew, Antonio. Relieved of some of his responsibilities, Matteo turned his attention to building up his property 'portfolio'. He expanded his family home by acquiring an adjoining house and, after inheriting a farm in the Mugello region just north of Florence, he elected to buy two more nearby. Most impressively, in 1454 Matteo bought a large villa, built by the noble Fini family in the fourteenth century, on the slopes of Fiesole overlooking Florence (see fig. 39).[19] This villa has long been identified with the villa described in the *Decameron,* a collection of novellas written in the Tuscan vernacular between 1348 and 1353 by Giovanni Boccaccio (1313–1375). The book is set in a secluded villa just outside Florence where a group of young men and women have fled to escape the Black Death, the plague ravaging the city in 1348. To pass the evenings, every member of the party tells a story each night. The various tales recounted in the *Decameron* range from the erotic to the tragic and from the witty to the edifying. The villa itself, with its idyllic gardens and fountains, is described by Boccaccio in his Introduction to the Third Day and is discussed in greater depth in Chapter 3.[20] Appropriately, the main road now giving access to the Villa Palmieri, the Via Boccaccio, is named after the poet.

Palmieri's humanist studies and early writings

Much of what we know about Palmieri's humanist interests and about the members of his social and intellectual circle can be gleaned from his own writings, particularly, his treatise, *Della Vita Civile (On Civic Life),* begun around 1431 and completed by 1439, his eulogy for Carlo Marsuppini of 1453 and his chronicle *De Temporibus (The Book of Epochs)* of 1448.[21] The content of *Della Vita Civile,* which describes the qualities of an ideal citizen, draws upon ancient treatises on citizenship by historians and rhetoricians such as Quintilian, Cicero and Plutarch, as well as Palmieri's own personal experiences. The text underscores the importance of early childhood education in creating politically and socially engaged citizens who go on

11

FRANCESCO BOTTICINI
Detail from *The Assumption of the Virgin,* showing Niccolosa de' Serragli, Palmieri's wife, and an unidentified city in the background.

to play an active role in city life and support those in their community. Palmieri mentions his own humanist training in the treatise, revealing that he was taught rhetoric and grammar by the Pistoian priest Giovanni Sozomeno (1387–1458), a highly respected intellectual with an impressive library, who also taught important members of leading Florentine families such as Pandolfo Pandolfini and Bartolomeo di Palla Strozzi.[22]

Palmieri describes himself as a disciple of the humanist and Chancellor of the Florentine Republic, Carlo Marsuppini (1399–1453), in the eulogy he was honoured to give at his funeral. Marsuppini, like Sozomeno, taught poetry, rhetoric, philosophy, ethics, Latin and Greek in the Florentine *Studio* (an educational institution similar to an academy).[23] Palmieri also appears to have been on familiar terms with Leonardo Bruni (around 1370–1444), the great Florentine historian and statesman whose monumental *Historiarum Florentini populi libri XII* (*History of the Florentine People in Twelve Books*), completed in 1442, is considered one of the first modern historical texts. Bruni's *History* probably inspired Palmieri's historical writings. These include two chronicles: the *Annales* (or *Historia Florentina*), which records the most important events occurring in the city between 1431–4, and the *De Temporibus,* a chronicle of the world from the time of Creation to 1448, written primarily to praise the greatness of Florence. Palmieri would also go on to write two works of narrative history: a biography of the Florentine statesman Niccolò Acciaioli, in 1440, and the *De Captivitate Pisarum Liber* (*The Capture of Pisa*), an account of Florence's victory over Pisa in 1406, written around 1448–50.

Together, Palmieri and Bruni were among the group of intellectuals who regularly met for study and debate at the Camaldolese monastery of Santa Maria degli Angeli in Florence under its Prior General, Ambrogio Traversari (1386–1439). Traversari, a monk, distinguished theologian and humanist scholar, translated many ancient texts including the work of Origen, a third-century Church Father (an authoritative early Christian theologian whose writings formulated and confirmed official church doctrine). Origen was also of particular interest to this group of Florentine scholars as he was a Neo-Platonist theologian – a Christian who studied the works of the ancient Greek philosopher Plato (428/7 or 424/3–348/7 BC) and his followers, and identified the Neoplatonic One, or God, with Jehovah, the God of Israel as described in the Hebrew Bible. It was most likely through Traversari that Palmieri became interested in Origen, whose more provocative and heretical ideas he would incorporate into his poem, the *Città di Vita* (see Chapter 2).

In addition to Italian and Latin, Palmieri appears to have had a reasonable knowledge of Greek, a language much used in the discussions at Santa Maria degli Angeli. His understanding of Greek is further attested by his presence at the Council of Florence in 1439 (as indicated in the *De Temporibus*). This ecumenical council brought together leaders of the Eastern and Roman Catholic Churches in the hope of reaching an agreement on their doctrinal differences, and was held in Latin and Greek.[24] Of Palmieri's many teachers, Traversari seems to have left the strongest impression. While Palmieri's earlier works reveal a preference for the ancient works of Cicero, Sallust, Quintilian and Aristotle, his later texts, including the *Città di Vita*, show an increased interest in the writings of the Greek and Latin Church Fathers so praised by the Camaldolese Prior.

While these figures were clearly key in shaping Palmieri's spiritual and intellectual ideas, a closer look at his works suggests he also turned to more poetic literary sources including Boccaccio and Dante. The fact that Palmieri wrote *Della Vita Civile* in Italian rather than Latin is a statement in itself. Like Dante, who was an early champion of vernacular literature and who wrote his *Divine Comedy* in Italian rather than Latin in order to reach a broader readership, Palmieri wanted his civic treatise to teach and help others. Divided into four books, *Della Vita Civile* consists of a series of dialogues between three interlocutors that takes place in a villa in the Mugello region just outside Florence where they have taken refuge from the plague of 1430. Although the dialogues are largely fictional, the interlocutors are real members of Palmieri's own circle: Franco Sacchetti, Luigi Guicciardini and Agnolo Pandolfini. The premise of the story is borrowed directly from Boccaccio's *Decameron*. In Book One of *Della Vita Civile*, discussions focus on the importance of educating citizens from childhood to maturity. Book Two begins with an appeal to study ancient philosophy, and goes on to discuss the cardinal virtues of Justice, Prudence, Temperance, and Fortitude, while Books Three and Four explore the practical aspects of these virtues in a manner resembling Cicero's *De Officiis* (*On Duties*).[25] In his discussion of the cardinal virtues in Book Three of the treatise, Palmieri promotes the related notion of *magnificenza* (munificence or magnificence), a virtue that could only be exercised by the rich and powerful, whom he encourages to spend money on honourable and glorious things for civic edification and public good, rather than for private enjoyment. Palmieri especially commends the building and decoration of churches, theatres, and loggias and the support of public festivals, games and banquets.[26]

The treatise as a whole endorses a notion of utilitarianism, the belief that actions are right if they are useful or for the benefit of a majority, and argues that the individual must sacrifice his or her personal comfort for the common good (*l'utilità commune*).

The Paradise vision as a literary motif

Palmieri's *Della Vita Civile* ends, rather curiously, with an account of a dying soldier's vision of the celestial spheres and of Heaven in a way that recalls Dante's description of Paradise in the *Divine Comedy* – as a series of concentric spheres surrounding the Earth, consisting of the Moon, Mercury, Venus, the Sun, Mars, Jupiter, Saturn, the Fixed Stars, the *Primum Mobile* (Prime Mover) and finally, the Empyrean Heaven.[27] While an otherworldly vision may seem an unusual way to conclude a civic treatise, the structure is one that imitates several famous ancient works such as Plato's *Republic* (which concludes with the vision of Er the Armenian) and Cicero's *De Republica* (which ends with Scipio's dream-like vision of the afterlife). At the conclusion of *Della Vita Civile*, Palmieri also refers to Dante's vision of a dead soldier during the Battle of Campaldino.[28] This literary formula of the 'vision' is repeated again by Leonardo Dati (1408–1472) in his commentary on Palmieri's *Città di Vita*. Dati claims that Palmieri was inspired to write the poem after his dead friend Cipriano Rucellai appeared to him while he visited the church of San Brigida in a monastery known as *Paradiso*. In this vision, Rucellai apparently told Palmieri that he had been sent from Heaven to reveal to him the true nature of Paradise and the destiny of man.[29] Although Rucellai had asked Palmieri to record this vision faithfully, it was only when he reappeared for a second time that Matteo wrote down the account in the form of a long, theological poem, the *Città di Vita*, in the manner of Dante's *Divine Comedy*. We will return to Dante and Palmieri's poems, and to a deeper exploration of these visions of Paradise, in Chapter 2.

Palmieri as politician

In 1431, the same year Matteo began recording events for his *Annales* and writing *Della Vita Civile,* he also held his first role in government as one of the *Otto Sindaci del Podestà*, eight syndics charged with ensuring that the chief magistrate of the city (the *Podestà*) did not transgress the limits of his

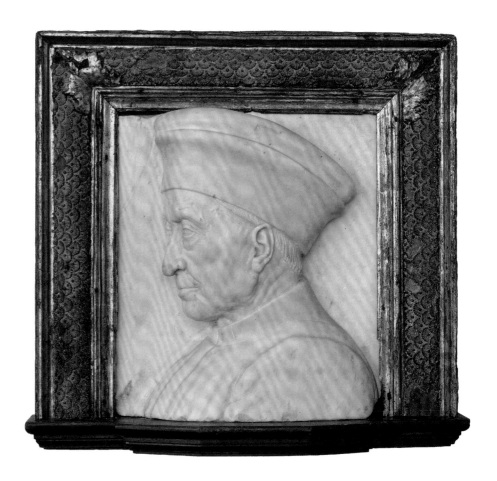

12

Workshop of ANTONIO ROSSELLINO
Cosimo de' Medici, the Elder, around 1460
Marble relief, 36 × 32 cm
Skulpturensammlung und Museum
für Byzantinische Kunst, Staatliche
Museen zu Berlin, Berlin

duty during his term of office. Just a few years later, Matteo gained a seat on the *Balìa*, a temporary committee given power for a limited term, formed to welcome back the exiled Medici. Cosimo de' Medici (fig. 12), who had long wielded tremendous political power without occupying public office, had been expelled from the city by an anti-Medicean faction in 1433. In leaving Florence, however, Cosimo had taken his bank and supporters along with him and, within a year, this flight of capital proved unsustainable for the city and the exile had to be lifted. In taking up his place on the *Balìa*, and more explicitly in his *Annales*, Palmieri openly expressed his approval of the return of the Medici to Florence. This was an early indication of the increasingly important role he would play in their regime.

From his first role in government onwards, Palmieri held communal office almost every year until his death in 1475. He held most of the senior governmental posts during his lifetime and attained the most prestigious position, *Gonfaloniere di Giustizia*, in 1453. He held a variety of judicial and economic offices, serving, for example, as one of the *Gonfalonieri di Compagnia* (a group responsible for administering justice and for commanding the people's militia), and as an official for the *Monte* (a financial institution which operated like a bank). He also served time as a *Conservatore delle Leggi* (Keeper of the Laws), a *Segretario dello Scrutinio* (an official responsible for

the scrutiny, a process of successive qualification of candidates for specific offices), and as one of the *Otto di Guardia* (a powerful magistracy that implemented the sentences of criminal courts).[30] These last two positions were key for the maintenance of Medicean hegemony in Florence.

Several speeches and political arguments made by Palmieri are preserved in the records of the *Consulta e Pratica,* an advisory commission convened by the Florentine government (*Signoria*) who invited key citizens to address controversial subjects. In these records, Palmieri's arguments are often made on the side of public good, and recall those put forth in his treatise, *Della Vita Civile*. For example, in the *Pratica*, Palmieri supported a new tax on citizens to pay soldiers who he felt were key to maintaining Florence's independence. He also demonstrated acute political analysis in recommending that Florence provide a subsidy to strengthen the military forces of Milan, her ally, ensuring that Venice did not become emboldened to attack the Milanese.[31]

When considering Palmieri's political and military decisions, it is important to keep in mind that Italy was not yet a unified country (the unification of most of present-day Italy would not take place until between 1859 and 1866). During the Renaissance, the peninsula consisted of a series of independent city states, papal states (i.e. territories under the sovereign direct rule of the pope) and the Kingdom of Sicily (Naples). War between the city-states was endemic, and decades of fighting eventually saw Florence, Milan and Venice emerge as the dominant players. These three powers finally signed a treaty, known as the Peace of Lodi, in 1454, after which a period of relative calm ensued until a series of conflicts, now known as the Italian Wars (1494–1559), erupted once again.

Palmieri as Florentine Ambassador

It is testimony to Palmieri's rhetorical and diplomatic skills that on several occasions, he was selected to act as an ambassador on behalf of the Florentine Republic. He was sent on diplomatic missions to Perugia (1452), Naples (1455), Lunigiana (an historical territory that now falls within the provinces of La Spezia and Massa Carrara) (1458), Rome (1466; 1468; 1473), Milan (1467) and Bologna (1466). For the most part, these embassies involved peace and trade negotiations between the various city-states, and the establishment and maintenance of various alliances between Florence and other powerful cities such as Venice, Naples and Milan.

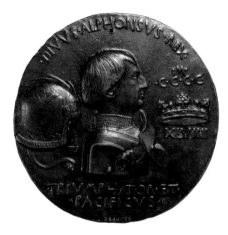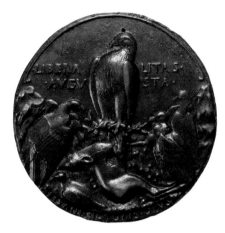

13

PISANELLO
Medal of Alfonso V, King of Naples, 1449,
obverse and reverse
Bronze, diameter 11.1 cm
Victoria and Albert Museum, London

This double-sided bronze medal is
decorated on the obverse with the
portrait of Alfonso V in profile, wearing
armour over chainmail, inscribed DIVVS.
ALPHONSVS. REX.– .TRIVMPHATOR. ET./
.PACIFICVS (The divine Alfonso, king,
victor and peacemaker). The reverse
is inscribed LIBERALITAS./AVGVSTA
(Imperial Liberality) and shows an eagle,
believed to hunt to feed both itself and
other, lesser, birds, perched above a dead
fawn and smaller birds of prey. Medals
such as this were intended to celebrate
a particular figure or event and were
often used as diplomatic or personal
gifts that were eagerly collected by
humanist scholars.

Palmieri's 1455 embassy to Naples is of particular interest. It appears
that he was selected for this mission as much for his humanist interests and
oratorical skills as for his diplomacy. As Palmieri's biographer Vespasiano
indicates, these qualities marked him out as a particularly suitable
ambassador to the Neapolitan court.[32] The Kingdom of Naples had been
united with the Kingdom of Sicily under Alfonso V of Aragon (1396–1458)
in 1443 (fig. 13). Known as Alfonso the Magnanimous, the monarch was not
only King of Naples and Aragon but also of Valencia, Majorca, Sardinia,
Corsica and Sicily, and was Count of Barcelona. One of the most powerful
figures of his day, Alfonso was also a lover of classical literature and
together with the poet Antonio Beccadelli (1394–1471), helped found a
learned society for scholars and humanists, which met regularly at his
castle in Naples. According to Vespasiano, the academic circles at the court
of Naples were familiar with Palmieri's works and esteemed him greatly.[33]
Palmieri's embassy was of the utmost importance to Florence, as Naples
had declared war on the city in 1452 when King Alfonso was trying to
establish a foothold in Tuscany. This terrified the greater Italian city-states
and Venice, for example, fearful of losing its independence from the allied
city-states of Florence and Milan, elected to ally itself with Naples. It was
only after lengthy negotiations that Florence, Venice and Milan signed a
peace treaty. Alfonso, however, refused to join unless the smaller allied cities
of Genoa and Rimini were excluded from the treaty because of previous,
and as yet unforgiven, differences. It was at this point that Palmieri was
sent to Naples to negotiate the final agreement, and to try to persuade the
King to renounce his interest in Genoa. Palmieri was also to reassert the
government's position regarding a group of exiled Florentine rebels whom
the King wanted to reinstate, to make the Florentine government's case for
imposing duties on goods coming from the Neapolitan kingdom, and, finally,
to establish good relations with the King and convince him of Florence's
friendly disposition. Palmieri's diplomatic skills ensured his success in all
of these tasks and a perpetual truce was signed between the Genoese and
the King shortly after his embassy.

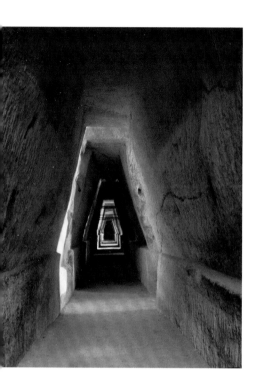

14
Present-day view of the ancient
Cave of the Cumaean Sibyl,
Campi Flegrei, Campania, Italy.

According to one account of the first meeting between Palmieri and the King, Matteo addressed Alfonso in Latin, Italian and Spanish and the King, complimenting Palmieri on his eloquence and language skills, was astonished to discover that he was an apothecary by trade and background, exclaiming, 'Imagine what the doctors (*medici*) are like in Florence if the apothecaries are like this!'[34] While this witty play on the word *medici,* referring both to medical doctors and to the Medici rulers of Florence, sounds somewhat apocryphal, a second reference to this meeting, this time written by Matteo himself, suggests that the two men held each other in great esteem.

Palmieri opens his epic poem, the *Città di Vita*, in Naples during his embassy to the King, and relates how the monarch took him to Cuma to visit the caves of the Sibyl, one of several ancient prophetesses believed to dwell at various holy sites and to foretell the future (fig. 14). Matteo recounts how, that night, his soul abandoned his sleeping body and joined the Sibyl in her cave, where he implored the prophetess to reveal the origin and destiny of the soul to him.[35] The entire poem is written in the style of a vision in which the Sibyl guides Palmieri through Heaven and Hell, explaining the various sights they encounter, much as Virgil (and later Beatrice) guided Dante through the realms of the afterlife in the *Divine Comedy*. In his commentary on the poem, Leonardo Dati further reveals that while in Naples Palmieri experienced a second vision of his dead friend Rucellai who explained the nature of Man, the hierarchies of the celestial spheres and of the angels in Paradise, and pressed Palmieri (for the second time) to write all this down in a poem (see fig. 26).[36]

Palmieri's embassy to Naples clearly marks an important point in both his political career and intellectual development. If it is true that Alfonso was particularly taken with the Florentine humanist and took him to visit the caves of the Sibyl, it is very likely that he also showed Palmieri his extensive library, of which he was particularly proud. One of Alfonso's most treasured manuscripts was a deluxe edition of Dante's *Divine Comedy,* illuminated by Priamo della Quercia and Giovanni di Paolo around 1444–50 (see figs 20 and 21), an exquisite object that would have left a lasting impression on the Florentine humanist. Palmieri's experiences during his embassy to Naples, including his encounter with the humanist king, his visit to the caves of the Sibyl, the paradisiacal vision and, perhaps, a glimpse of this manuscript of the *Divine Comedy*, appear to have both prompted and formed the basis of his *Città di Vita*.

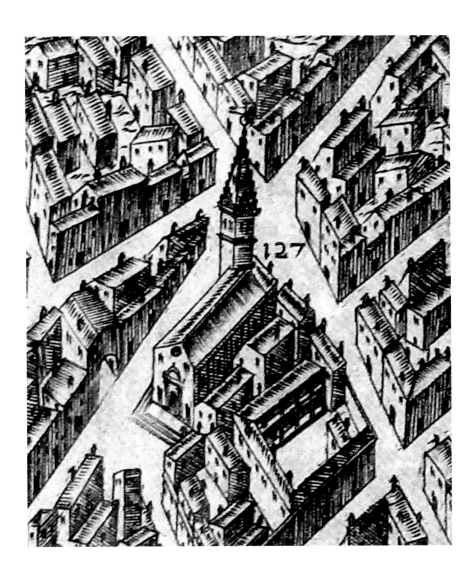

Palmieri's amicizie *or mutually beneficial friendships*

Palmieri was clearly a man who practised what he preached. In his *Della Vita Civile,* in a section on 'usefulness', Palmieri singles out different categories of useful things, one of which is *amicizia* (a word that signifies both kinship and friendship), relationships which, Palmieri argues, lead to glory and an honourable way of life.[37] Palmieri's networks of influential friends were often interconnected on several personal, social, economic and professional levels. They enjoyed a kind of *amicizia* that went beyond simple 'friendship' and might be better categorised as a kind of mutually beneficial bond or alliance between individuals or families.[38] The strongest evidence of Matteo's most important *amicizie* are found in the dedications of his written works. For example, he addressed *Della Vita Civile* of 1439 to Alessandro degli Alessandri, a Medici supporter who lived in the same quarter as the Palmieri family, on the Borgo San Pier Maggiore (now Via degli Albizzi) (fig. 15). Matteo and Alessandro served on the same *Balìa* committee in 1438 and,

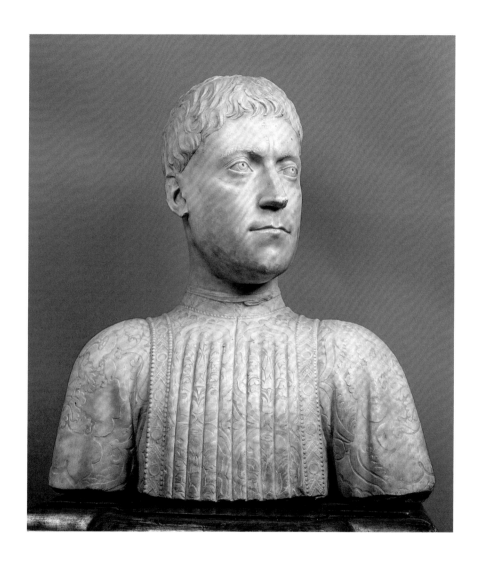

as Palmieri's tax records indicate, the Alessandri family were regulars at his apothecary shop at the Canto alle Rondini and owned the patronal rights to a chapel in the church of San Pier Maggiore.

Palmieri's *Vita Nicolai Acciaioli* (a Latin biography of Niccolò Acciaioli in the manner of Plutarch's biographies of famous men), written around 1440, is dedicated to his good friend, and Niccolò's descendant, Adovardo Acciaioli. Palmieri came to know Adovardo when they both served in the *Ufficio di Gonfaloniere di Compagnia* (Office of the Gonfalonier) from 1434–7 and the two evidently maintained a strong friendship thereafter. The Acciaioli were a noble banking family in Florence and Palmieri's biography

16

MINO DA FIESOLE
Portrait bust of Piero de' Medici,
known as 'il Gottoso' ('The Gouty'), 1453–4
Marble, height 54.5 cm
Museo Nazionale del Bargello, Florence

celebrates their most famous member, Niccolò (1310–1365), an important statesman and military leader who was also the friend and protector of the poets Petrarch and Boccaccio.

Similarly, Palmieri dedicated his Latin chronicle *De captivitate Pisarum* of about 1450 to Neri di Gino Capponi, whose father played a key role in Florence's victory over its long-time rival Pisa in 1406, after which the city and its valuable port access became subject to Florence. Neri Capponi was a powerful and well-respected man who moved in the same political circles as Palmieri, serving, for example on the *Balìa* of 1440 with Alessandro degli Alessandri and Cosimo de' Medici, and distinguishing himself as a commissioner with the Florentine militia against the Milanese at the Battle of Anghiari. It was, however, more probably Capponi's work as an historian and his commentary on the war with Pisa (*Commentari della Guerra o dell'acquisto di Pisa seguita l'anno 1406*) that inspired Matteo to dedicate his chronicle on the same subject to him. It is clear that the *amicizie* between these men developed within the humanist circles in which they studied, the government committees on which they served, in the neighbourhoods they frequented and through the civic and spiritual events in which they participated.

It was Palmieri's *amicizia* with the Medici that had the most significant impact on his career. His support for the regime began as early as 1434 (if not earlier), when he formed part of the *Balìa* established to welcome back the exiled Medici and their supporters. In 1449 Palmieri's name appears on a list of 64 citizens loyal to Cosimo de' Medici that was drawn up when Medici partisans were failing to convince other Florentines to preserve the constitutional controls that would ensure the survival of the regime. Further, Cosimo's son Piero de' Medici (1416–1469) (fig. 16), seems to have established a friendship with Palmieri while under the tutelage of Carlo Marsuppini, and both Matteo and Piero were among the few individuals entrusted with planning the elaborate ceremonies for Marsuppini's state funeral in 1453.[39] In 1448, Palmieri dedicated his *De Temporibus* to Piero de' Medici and, writing from Naples in 1455, Matteo addresses him as his *amico singularissimo* (most singular friend).[40] It is no coincidence that when Piero took power after his father's death in 1464, Palmieri became increasingly involved in the city's affairs. While Palmieri held a different governmental position almost every year until his death just over a decade later, he increasingly turned down opportunities to serve as ambassador in his later years, stating that he was too old and infirm to travel.[41] He died, at the age of 69, in 1475.

PIANTA E'TAGLIO, DELLA CHIESA, DI S. PIER'MAGGIORE

Il Convento di questa Chiesa e di una cattiva Struttura e Disegno, come e
la Chiesa, e per Orto anno, un Cortile molto Grande.

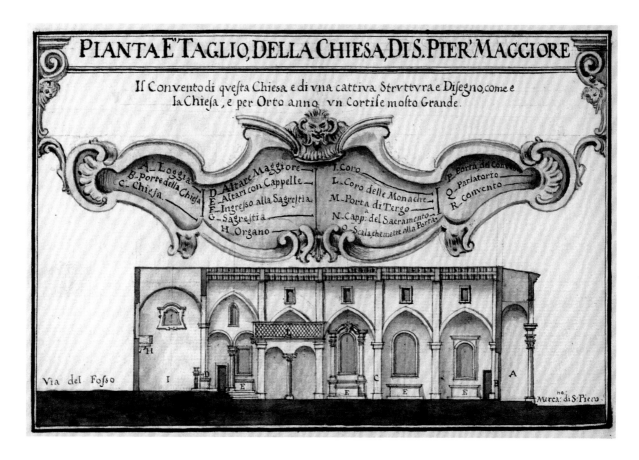

A. Loggia
B. Porte della Chiesa
C. Chiesa
D. Altare Maggiore
E. Altari con Cappelle
F. Ingresso alla Sagrestia
G. Sagrestia
H. Organo
I. Coro
L. Coro delle Monache
M. Porta di Tergo
N. Capp: del Sacramento
O. Scala che mette alla Porta
P. Porta del Convento
Q. Parlatorio
R. Convento

Via del Fosso

Merca: di S. Piero

Via del Fosso

Mercatino di S. Piero

Stanza dei Preti

Monache

Botteghe delle Pianellai

Via dei

Braccia. 40.

Palmieri's funeral and chapel in San Pier Maggiore

At his death, Palmieri was given a public state funeral in the church of San Pier Maggiore in recognition of his services to the Florentine republic, an exceptionally rare honour that required special permission from the *Priori*, one of the nine individuals that made up the Florentine government or *Signoria*. A public funeral was normally reserved for those who had served as Chancellor of Florence, a title Palmieri never held, and other than Leonardo Bruni, only Carlo Marsuppini, Coluccio Salutati and Cosimo de' Medici were accorded that honour in the fifteenth century. It was Palmieri's great friend and fellow humanist, Alamanno Rinuccini (1426–1499), who delivered the funeral oration on 15 April 1475. Rinuccini, like Palmieri, was born into a family of merchants, but preferred Neoplatonic philosophy to commerce. He translated the works of ancient Greek authors such as Plutarch and Apollonius into Latin, and served on several councils of the Florentine government including a *Balìa* formed in 1466 by Piero de' Medici to exile his opponents after the conspiracy of Luca Pitti. Fortunately, Rinuccini's funeral oration was preserved and later published, confirming that a copy of the *Città di Vita* was placed on Palmieri's chest during the funeral service, according to his wishes.[42] Following the ceremony, the body was laid to rest alongside those of his father and uncle in the family vault located beneath the nuns' choir in the right aisle of San Pier Maggiore (the area marked 'L' on the plan in fig. 17).[43]

The funeral was a great public event and was attended by all of the most important figures in Florence including Piero's son, Lorenzo de' Medici, known as '*il Magnifico*' (the Magnificent). Rinuccini's oration was full of admiration for Palmieri, whom he described as increasing his wealth through frugality and honest industriousness, which brought the humanist fame and honour and allowed him to construct magnificent buildings and to endow religious foundations honouring God.[44] One such foundation was, of course, the church of San Pier Maggiore where, in his testament of 1469, Palmieri had indicated his desire to be buried. It was only after Matteo's death, however, that his wife and heirs were able to secure patronal rights to a chapel in the right hand (south) transept of the church. Although Palmieri had commissioned Botticini's altarpiece before his death, it would take at least two more years until work on both the painting and the chapel was complete. A document dated June 1477 indicates that the painting had been completed and delivered by then.[45]

17
Elevation and plan of San Pier Maggiore, Florence, prior to the building's partial destruction. Graphite, pen and ink, with red, green and grey wash, before 1784
National Archives, Prague
(Family Archives of Habsburg-Tuscany, Maps, Cabreo BA 55, no. 17)

The Palmieri family shared the patronal rights to the south transept and their chapel was probably located at the top left of this plan.

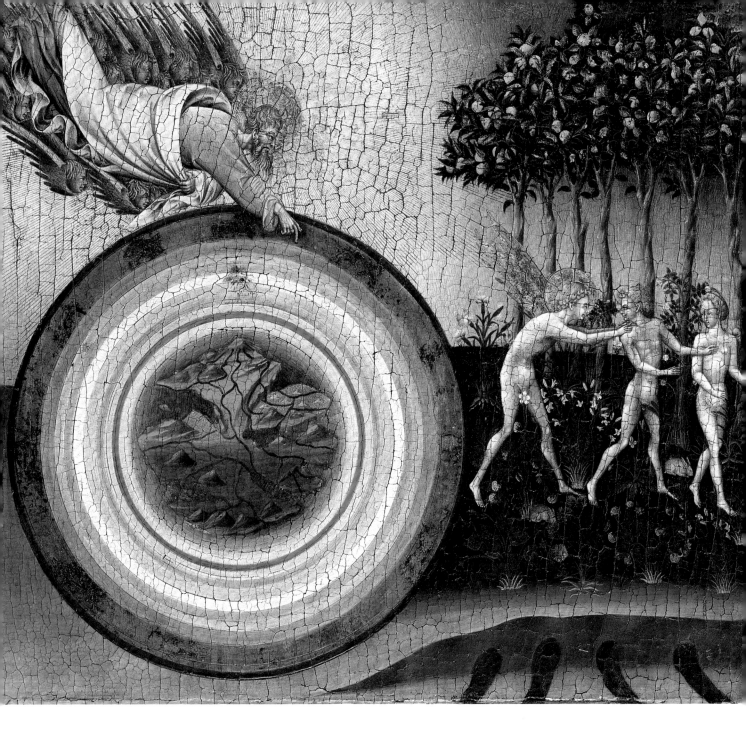

2 Painting the Cosmos: Heaven and Earth

18

GIOVANNI DI PAOLO
*The Creation of the World and
the Expulsion from Paradise*, 1445
Tempera and gold on wood, 46.4 × 52.1 cm
The Metropolitan Museum of Art,
New York
(Robert Lehman Collection 1975.1.31)

God the Father swoops down from
the sky, flanked by cherubim, to 'animate'
the celestial spheres. Here, the Universe
is represented as a map of the Earth
surrounded by twelve colour-coded
concentric circles each corresponding
to the elements and the celestial spheres in
Dante's model. To the right, an angel drives
Adam and Eve from the Garden of Eden.
Below them are the four rivers of Paradise.

Renaissance viewers of Botticini's monumental altarpiece would have recognised the landscape, hilltop plateau and the dome above as representing their understanding of the Universe, comprising the Earth, Paradise and Heaven. These conceptions were reiterated and developed further by Dante in the *Divine Comedy*, which in turn served as the primary model for Palmieri's *Città di Vita*. This chapter begins with an explanation of Late Medieval and Renaissance conceptions of the Universe, in order to demonstrate how these are reflected in Botticini's dramatic composition. The spheres of Paradise and Heaven as represented in the painting are the focus of this chapter, while the earthly realm is treated more fully in the following one.

Early models of the Universe

Ancient Greek philosophers developed cosmological models of the universe in which the planets and stars were embedded in a series of concentric spheres made of 'quintessence', an ethereal, transparent fifth element. Aristotle (384–322 BC), for example, described a cosmology in which these nested celestial spheres rotated, with uniform motion, around a central, stationary Earth.[1] He argued that the movement of each of these spheres (the Moon, Mercury, Venus, the Sun, Mars, Jupiter, Saturn and the Fixed Stars) was governed by its own planetary god (a mover) and that beyond them was a ninth sphere, which he called the *Primum Mobile* (or 'Prime Mover'), that affected all the subordinate spheres.

Christian philosophers and theologians subsequently adapted this model to include an outermost region, called the Empyrean Heaven (the firmament or highest heaven), which they identified as the dwelling place of God and of the elect. They also argued that the lower (inner) spheres were moved by spiritual movers called intelligences, who they equated with angels, and identified the 'Prime Mover' with God (fig. 18).[2]

19

GIOVANNI DI PAOLO
Paradise, 1445
Tempera and gold on canvas,
transferred from wood, 47 × 40.6 cm
The Metropolitan Museum of Art,
New York (Rogers Fund, 1906.1046)

Paradise is painted with abundant
orange trees, hares, flowers and
lush greenery, populated with
groups of embracing saints and
angels. At the upper right, an angel
(or perhaps a young woman) leads
a young man towards a stream of
golden light, presumably a gate to
the celestial city of Heaven. The
souls in this panel are in the Earthly
Paradise, as described by Dante,
which they have attained through
climbing the Mount of Purgatory.

Locating Paradise

The word 'paradise' comes from the Latin *paradisus*, which is in turn derived
from Greek and Old Iranian terms signifying a park, garden or walled
enclosure. Accordingly, in the Judeo-Christian tradition, the term is used to
refer to the Garden of Eden or the Kingdom of God, or to the place where
the blessed souls await their entrance into a higher heaven (fig. 19).[3] From
an early date, however, theologians began making distinctions between
Paradise and Heaven. In the second century, for example, Irenaeus, Bishop of
Lugdunum (now Lyons, France) wrote that only the souls of those deemed
worthy would dwell in Heaven, while others would enjoy Paradise, and
the remaining souls would live in 'the city', that is, the restored Jerusalem.[4]
Similarly, the Church Father Origen described Paradise as the earthly 'school'
that prepared the souls of the virtuous for their ascent through the celestial
spheres to Heaven. Following these influential Church Fathers, many Early
Christians believed that Paradise was a place on Earth where the souls of the
righteous remained until the resurrection at the Last Judgement.

Dante's conception of the Universe

The Aristotelian model of the universe was taken up by Dante in his epic
poem, the *Divine Comedy*, written between about 1308 and 1320. In the poem,
Dante recounts his own dream-like journey through the three realms of the
afterlife: *Inferno* (Hell), *Purgatorio* (Purgatory) and *Paradiso* (Paradise). At the
opening of the poem, he finds himself lost in a dark wood, a metaphor for
his sense of ignorance and of entanglement in the vices of the world. He
is rescued by the spirit of the Roman poet, Virgil, who guides him through
Hell (described as a funnel descending into the centre of the Earth) and
Purgatory (a mountain rising from the surface of the Earth) (see fig. 22).
In Purgatory, Dante meets Beatrice, a woman he had loved in his youth but
who had died at a young age. Beatrice guides Dante to the Earthly Paradise
at the top of the Mount of Purgatory where she bids him drink from two
rivers, the Lethe, whose water erases the memory of past sin and the Eunoë,
which restores good memories. From Paradise, Dante ascends through the
celestial spheres, all the way to the Empyrean Heaven where he comes face
to face with God himself, and, finally, understands Christ's divine and human
nature. The poet's journey through the three realms serves as an account of
the soul's journey towards God and, ultimately, to salvation.

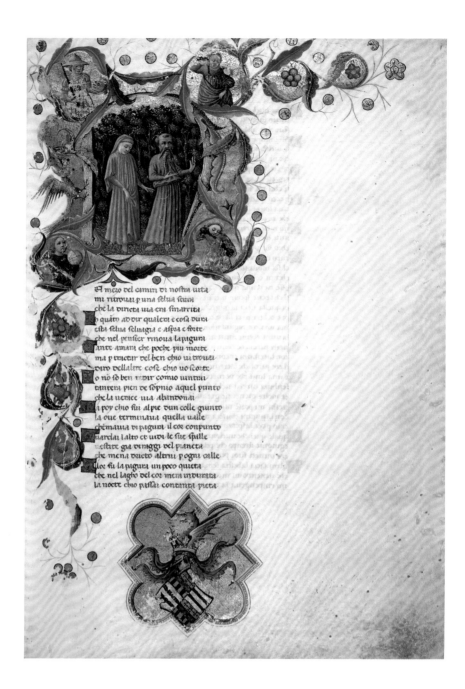

20

PRIAMO DELLA QUERCIA (illuminator)
La Divina Commedia, about 1444–50, fol.1
Manuscript, 36.5 × 25.8 cm
The British Library, London
(Yates Thompson 36 fol.1)

This opening page of the *Divine Comedy*
shows Dante and Virgil in a dark wood,
with four half-length figures representing
Justice, Power, Peace and Temperance.
The coat of arms of Alfonso V of Aragon
is depicted below.

Dante's legacy

The immediate and sustained fame of Dante's poem helped disseminate an
understanding of this geocentric conception of the universe, which largely
persisted until Nicolaus Copernicus revived the idea of the sun-centred
universe in the early sixteenth century.[5] Dante's vivid descriptions in the
Divine Comedy created rich material for illustrators, with the earliest illuminated
manuscripts appearing in Florence in the 1330s.[6] Commentaries on this
complex poem were written around this time and it soon became the subject
of close study in many Italian universities and was widely read aloud in
public, making it accessible even to the non-literate. In the fifteenth century,

GIOVANNI DI PAOLO (illuminator)
La Divina Commedia, about 1444–50
The British Library, London
(detail from Yates Thompson 36 fol.130)

'Heaven and Earth'. This illumination accompanies *Canto* I of the *Paradiso*. It shows Beatrice (in pink) hovering in the air with Dante (in blue), explaining the great sea of being, inhabited by creatures outside reason. At the upper left is a planetary symbol of the seven virtues while in the centre, the winged figure of Love presides over the heavenly spheres, represented as nine concentric circles.

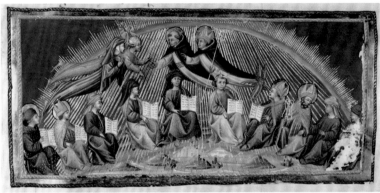

(detail from Yates Thompson 36 fol.147)

'The Sphere of the Sun'. This illumination accompanies *Canto* X of the *Paradiso*. It shows Dante and Beatrice in the sphere of the sun being greeted by Thomas Aquinas and Albertus Magnus. Beneath them are ten other great intellectual authorities (Doctors of the Church), including Bede, Ambrose, Isidore and Boethius. A distant Earth is just glimpsed below.

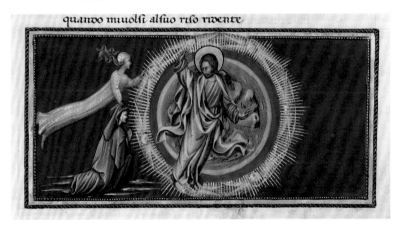

(detail from Yates Thompson 36 fol.178)

'Christ the Redeemer'. This illumination accompanies *Canto* XXVIII of the *Paradiso*. It shows Beatrice presenting Christ and the entire Cosmos to Dante, who falls to his knees and presses his hands together in prayer. Here the *Primum Mobile* is shown as a ring of golden light, framed by Cherubim and containing a diminutive map of the world at its centre, before which hovers the commanding figure of Christ.

illustrations of the poem became increasingly sophisticated and inventive, as, for example, in the manuscript of the *Divine Comedy* made around 1444–50 for Alfonso V of Aragon, King of Naples, the founder of a great humanist library. This large tome consisted of 190 leaves of vellum with 115 illuminations by Priamo della Quercia and Giovanni di Paolo (figs 20 and 21).

Giovanni di Paolo's illuminations for the *Paradiso* capture the spirit of Dante's poem while innovatively visualising the long, complex theological narrative. They established a new benchmark for illustrating the *Divine Comedy*. If Alfonso V did indeed show his manuscript to Palmieri during his visit to Naples in 1455 (as suggested in Chapter 1), it is not difficult to imagine the

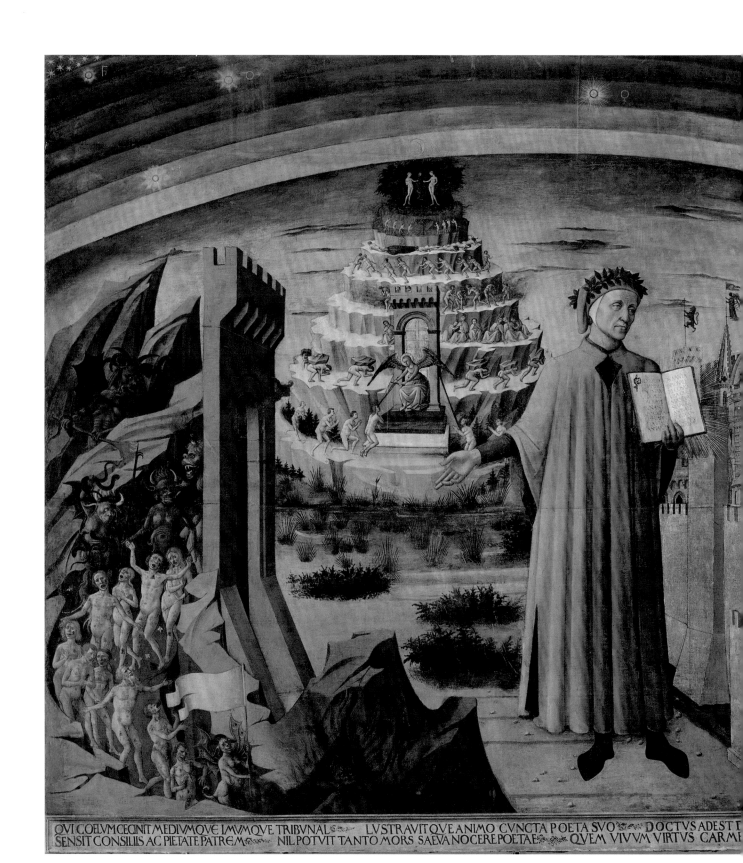

QVI COELVM CECINIT MEDIVMQVE IMVMQVE TRIBVNAL ❧ LVSTRAVITQVE ANIMO CVNCTA POETA SVO ❧ DOCTVS ADEST D
SENSIT CONSILIIS AC PIETATE PATREM ❧ NIL POTVIT TANTO MORS SAEVA NOCERE POETAE ❧ QVEM VIVVM VIRTVS CARMI

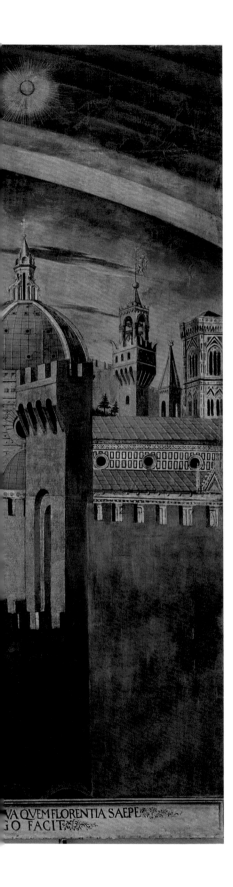

22
DOMENICO DI MICHELINO
Dante as the Poet of the 'Divine Comedy',
1465
Tempera on panel, 232.5 × 292 cm
Cathedral of Santa Maria del Fiore, Florence

lasting impact this would have had on the humanist and passionate patron of the arts. Palmieri may even have described aspects of the illuminations to Botticini when commissioning his altarpiece.[7] Indeed, Giovanni di Paolo's representation of the celestial spheres as concentric circles (fig. 21), and his Tuscan panoramas complete with mountain peaks, fortified city walls, towers and roads, all reappear in the Palmieri altarpiece.

Domenico di Michelino's Dante as the Poet of the 'Divine Comedy'

While Giovanni di Paolo's innovative manuscript illuminations provided new models for artists dealing with an increasing number of commissions with Dantesque themes, it was arguably Domenico di Michelino's *Dante as the Poet of the 'Divine Comedy'* (fig. 22), painted in 1465, that served as a more obvious model for Botticini's San Pier Maggiore altarpiece. This monumental panel (232.5 x 292 cm), made for the north wall of Florence's Cathedral, seems to have been commissioned to replace an earlier painting of Dante in the same location.[8] Michelino's work represents Dante holding a copy of the *Divine Comedy* inscribed with the first six lines of the poem, with golden rays issuing from it that literally illuminate the city of Florence. With his right hand Dante indicates a procession of sinners descending into the nine circles of Hell, while behind him, at the centre of the composition, are the seven terraces of the Mount of Purgatory, with Adam and Eve represented at the top to indicate the Earthly Paradise. The sky above is defined by concentric circles of increasingly darker shades of blue, each marked with the symbol of the planetary sphere it is intended to represent, with the sphere of the Fixed Stars just visible at the upper left-hand corner of the composition. The view of Florence in Michelino's painting is taken from the north looking south, a popular perspective for views of Florence before the creation of the 'Chain Map' by Francesco Rosselli in the 1480s (fig. 23) (discussed in Chapter 3), which represents the city from the south west.[9] On the right of the painting, immediately above and below Dante's open book, we see the

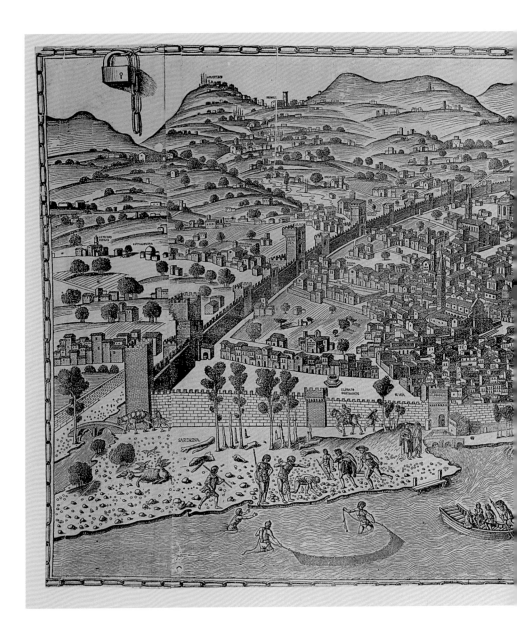

23
ANONYMOUS (attributed to LUCANTONIO
DEGLI UBERTI), after FRANCESCO ROSSELLI
View of Florence (The 'Chain Map'),
probably 1490s but possibly as late as 1510
Woodcut
Kupferstichkabinett, Staatliche Museen zu
Berlin-Preussischer Kulturbesitz, Berlin

Palazzo del Podestà, or Bargello, with a rampant lion on its weather vane,
as it still appears today, and immediately across the street we see the Badia,
identifiable by its hexagonal tower and angel weather vane. Dominating the
cityscape is the Duomo, the Cathedral of Santa Maria del Fiore, inside which
this painting still hangs. Projecting from behind the Cathedral nave is the tower
of the Palazzo della Signoria, the City Hall, and at the far right, Michelino
shows the Cathedral's campanile (bell tower) designed by Giotto.

Michelino's large panel was one both Palmieri and Botticini would have
known well and it would have been familiar to most Florentine citizens
due to its prominent position in the spiritual heart of the city. Botticini's
Assumption of the Virgin draws on Michelino's composition and, presumably,
the earlier work it replaced, both works with longstanding spiritual and civic
importance for Florentines; works that represented *their* poet and the key
monuments of *their* city in the heart of *their* cathedral. Botticini represents

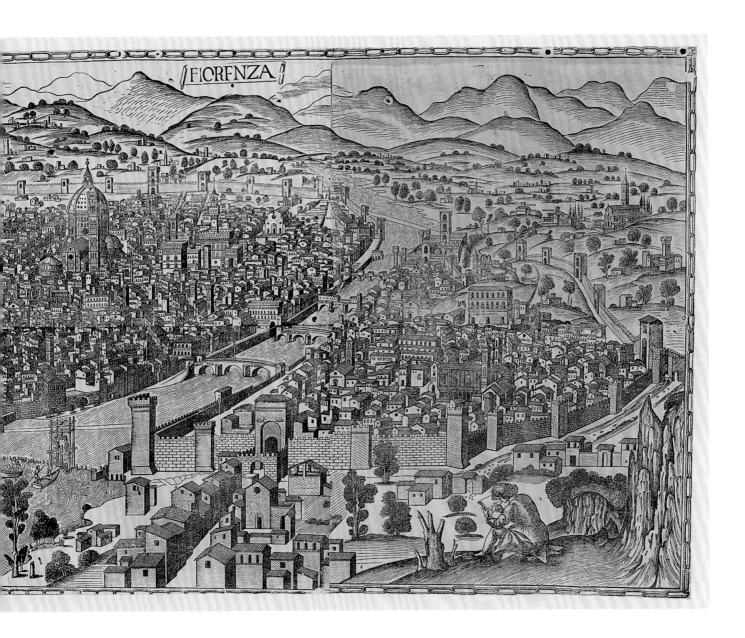

the city of Florence, like Michelino, from the north-east, locating Palmieri, the author of *La Città di Vita* and therefore a poet in his own right, parallel to the city as the new Dante (see fig. 5). Like the famous poet he emulates, Palmieri is represented wearing unmistakably Florentine garments, a red *lucco* (the long robe with arm slits) and a scarlet hood or *cappuccio* slung over his right shoulder. This official-looking attire simultaneously identifies Palmieri as a Florentine citizen and as one who serves in the Florentine government. Both Palmieri's dress and his proximity to the city, which is located immediately behind him, underscore his deep love, and years of service, for the city of his birth and recall his continuous refrain of the importance of '*l'utilità commune*' in his civic treatise, *Della Vita Civile*.[10]

Palmieri's location with respect to the city, however, is substantially different from that of Dante in Michelino's panel. Matteo, together with his wife, Niccolosa, kneeling opposite, and the apostles at the centre of

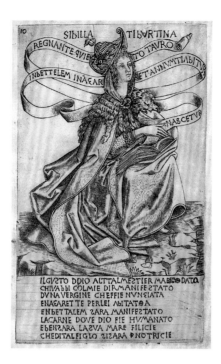

the composition, all occupy the tiered plateau of a raised mount that
overlooks the city, surrounding countryside and the chain of the Apennine
mountains in the distance. When read against Michelino's well-known
painting, it would seem that these figures have been transported to the top
of the Mount of Purgatory, that is, to the Earthly Paradise, with Matteo
and Niccolosa now occupying the places normally reserved for Adam and
Eve (see figs 2 and 22). This would suggest, in turn, that their souls were
being purified in advance of their (hoped for) ascent to the Celestial Paradise
above. In their raised position, they are closer to the celestial spheres, each
identified by a concentric circle of an increasingly deeper shade of blue.

Palmieri's conception of the Universe in the Città di Vita

Both the structure of Palmieri's *Città di Vita* and his description of the
Universe are modelled on Dante's *Divine Comedy*. Palmieri's poem, like
Dante's, describes a vision of the soul's journey through the realms of
Heaven, Hell and Purgatory and is organised around the number three,
a structure referring to the Trinity (the three persons of the Christian
Godhead: Father, Son and Holy Spirit). Both poems are composed in *terza
rima* (rhyming triplets) in the vernacular and consist of three *cantiche* (books)
each containing 33 *cantos* (divisions), although Palmieri adds an additional
canto to the last book. While Dante's poem certainly provided a literary and
structural model for Palmieri, the theology expressed in the *Città di Vita* is
markedly different to that in the *Divine Comedy*.

As Palmieri refers to his visit to Naples in the opening lines of the
Città di Vita he must have begun writing this long theological poem

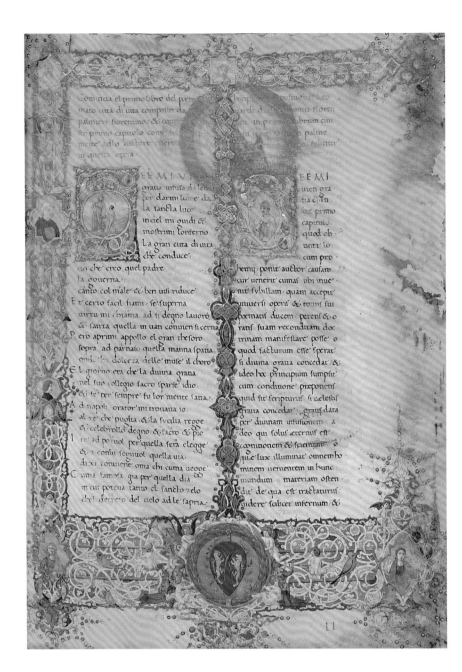

26

MATTEO PALMIERI (author)
Opening page of *La Città di Vita*,
illuminated by Francesco Botticini,
about 1473
Vellum manuscript, 38 × 28 cm
Biblioteca Medicea Laurenziana,
Florence (Plut. 40.53, fol. 11r)

In the far left margin is a portrait of
Palmieri accompanying his text. The right-
hand column contains Leonardo Dati's
Latin commentary, accompanied by his
portrait. At the upper left is a miniature
showing the soul of Palmieri (represented
as a naked child) accompanied by the
Cumaean Sibyl. At the bottom of the page
is the Palmieri coat of arms (see detail on
p. 17). The edges of the manuscript were
damaged during a flood.

following his embassy to that city in 1455 (fig. 26). We know from surviving
correspondence that he had finished the first draft of his poem in September
of 1464. Palmieri's poem begins just outside Naples, at Cuma where he had
paid a visit to the caves of the Cumaean Sibyl (see fig. 14). Sibyls were ancient
prophetesses believed to dwell at various holy sites and to foretell the future
(figs 24 and 25). Christians were especially interested in the Cumaean Sibyl
as she is described in Virgil's *Fourth Eclogue* as foretelling the coming of a
saviour whom they identified as Jesus. Palmieri describes how, at night while
his body was sleeping, his soul joined the Sibyl in her cave and begged the
prophetess to reveal to him the origin and destiny of the soul. While Palmieri's
visit to the caves may have inspired him to cast the Cumaean Sibyl as his guide

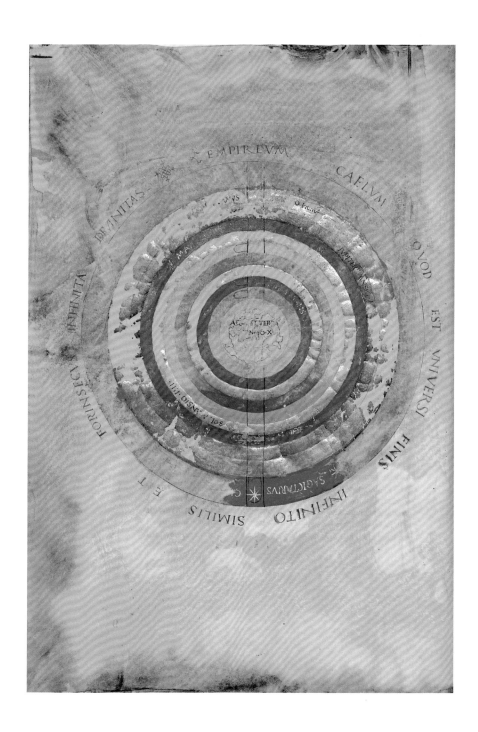

27

MATTEO PALMIERI (author)
La Città di Vita, about 1473
Vellum manuscript, 38 × 28 cm
Biblioteca Medicea Laurenziana,
Florence (Plut. 40.53, fol. 9v)

This geocentric universe places the
Earth at the centre surrounded by
water. Beyond are the celestial spheres
– the Moon, Mercury, Venus, the Sun,
Mars, Jupiter, Saturn, and the Fixed
Stars (where Palmieri locates the Elysian
Fields), followed by the Empyrean
Heaven, all represented as a series of
concentric circles in differing colours.

in the poem, he must have also had in mind the Roman poet Virgil's description
of her as Aeneas' guide to the Underworld in his epic poem, the *Aeneid*.[11]

In the First Book of the *Città di Vita,* the Cumaean Sibyl explains Creation
and the nature of God and the Universe to Palmieri. She further reveals that
the 'Città di Vita' (or 'City of Life') comprises the entire universe, including
everything that lives, feels and breathes (fig. 27).[12] According to the Sibyl,
God was originally accompanied by an infinite number of angels in the
Empyrean Heaven. However, during the subsequent war in Heaven between
God and Lucifer, some of the angels rebelled and were cast down to Hell.[13]

Others, following the Archangel Michael, sided with God and remained in Heaven, while a third group of angels found themselves unable to make up their minds as to which group to join and remained neutral. The Sibyl explains that these neutral angels were then sent to the Elysian Fields (a place traditionally described by the ancient Greeks as a paradisiacal land of plenty where the heroic and righteous dead spent eternity) from which they descended down to Earth and took on human form. On Earth they exercised free will, that is, they acted at their own discretion rather than being ruled by fate, and were given a second chance to choose between good and evil. Depending on their choice, they would then either ascend to Heaven, returning to their original angelic form, or else be condemned to Hell.

This provocative notion of the pre-existence and angelic origins of the human soul and the notion of free will were all promoted by Origen. His views were deemed heretical by some scholars and theologians. They argued that the notion that the souls pre-exist human conception challenges Christian beliefs that the human soul is generated by the souls of an individual's parents or that God creates a soul for each body that is generated. Origen's promotion of free will was also considered problematic as, although orthodox Christian teaching tends to affirm free will, it does not suggest that the exercise of that will can win (or lose) an individual's salvation, an achievement only attained through God's grace.

The poet's journey from the Empyrean and the Elysian Fields down through the celestial spheres towards Earth and then through Hell in the *Città di Vita* reverses that taken by Dante in the *Divine Comedy*. This reversal is key to the main argument of Palmieri's poem: that the human soul has pre-existing and angelic origins. In Palmieri's model of the universe, the Elysian Fields (normally associated with Earthly Paradise) are located beyond the planetary spheres in the realm of the Fixed Stars.[14] The neutral angels, as the Sibyl explains, must remain in the Elysian Fields until their bodily descent to Earth. On their journey down, each soul is accompanied by two angels, one from Heaven, the other from Hell, each of which vies for that soul's allegiance. The souls descend through the seven spheres of the planets and the three spheres of the elements (fire, air, water). On their journey, the souls absorb qualities associated with each of the spheres they pass through, such as military valour in the realm of Mars, prudence in Saturn and beauty in Venus. Just before alighting on Earth, the souls drink from the river Lethe in order to forget their former heavenly existence, in contrast to Dante's souls who drink from the same river to forget their sins.

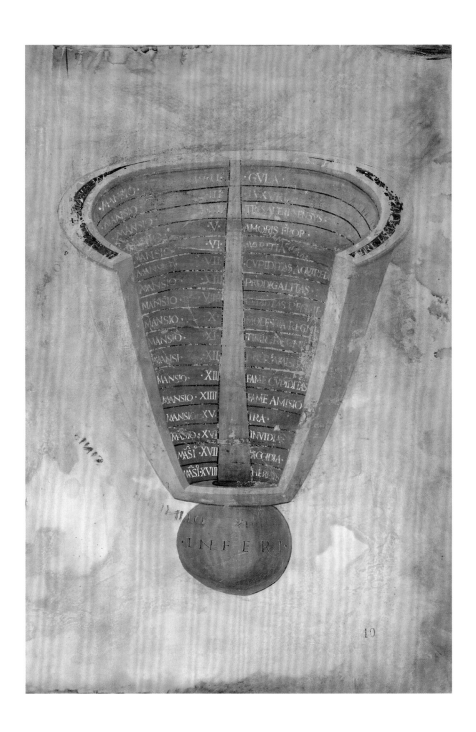

28

MATTEO PALMIERI (author)
La Città di Vita, about 1473
Vellum manuscript, 38 × 28 cm
Biblioteca Medicea Laurenziana,
Florence (Plut. 40.53, fol. 10r)

In Palmieri's conception of Hell there
are eighteen levels, called 'mansions',
containing souls suffering from various
sins and vices. A staircase rises from
the lowest level of Hell, the summit of
which marks the realm of the Blessed.

Book II of the *Città di Vita* describes Palmieri and the Sibyl's journey
from the Earthly realm through the '*selva oscura*' (or 'dark forest') down
through Hell. They are led through this realm by Cacogenio, a wicked
angel, who guides them through all 18 levels, called 'mansions', of Hell
where they encounter souls suffering from every vice and sin including
sloth, desire, luxury, anger and envy (fig. 28). Arriving at the lowest level
of Hell, Palmieri sees a staircase rising up before him, whose summit is
bathed in a bright light, marking the realm of the Blessed, which beckons
him upwards.

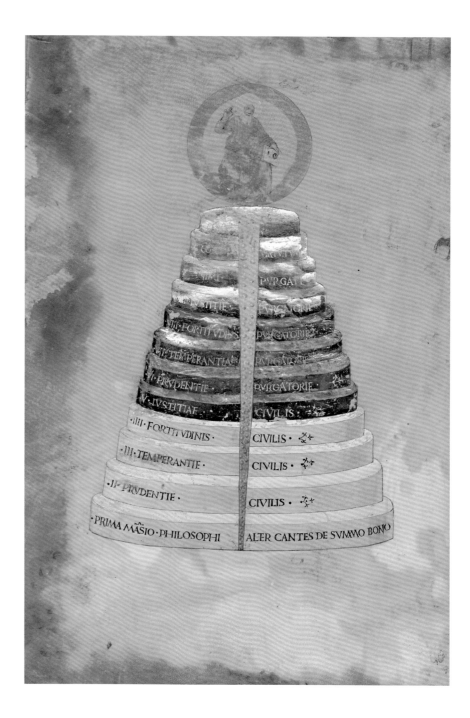

29

MATTEO PALMIERI (author)
La Città di Vita, about 1473
Vellum manuscript, 38 × 28 cm
Biblioteca Medicea Laurenziana,
Florence (Plut. 40.53, fol. 10v)

The Mount of Virtues is subdivided
into three orders, the first representing
the Civic Virtues (in white), the second
the Purgative Virtues (in black) and
the third the Blessed (in gold) who
unite their virtues with a love of Christ.
At the top of the Mount is God the
Father seated in Glory making a gesture
of blessing and holding an open book
inscribed with the Alpha and Omega.

In the opening of Book III, Palmieri meets a good angel, called
Calogenio, who points him and the Cumaean Sibyl towards the 'mountain
of the virtues', reminiscent of Dante's Mount of Purgatory (fig. 29). In the
Città di Vita, however, Purgatory and Paradise are conceived as a single
realm that constitutes the '*via che mena in cielo*' (the path that leads to
Heaven). In merging these realms, Palmieri shifted the focus from the
nature of Purgatory, as discussed by Dante, to the pre-existence of souls.

Climbing this Mount of Virtues, Palmieri proceeds through each of
its three orders, the first representing the Civic Virtues, the second the

Purgative Virtues and the third the Blessed, who unite their virtues with a love of Christ. Among this last order is John the Baptist, the precursor and baptiser of Christ. More resplendent and higher up than all other creatures is the Virgin Mary, who appears in Glory and is described simultaneously as Virgin, Mother and Bride of Christ.[15] She is crowned as the Queen of Heaven and is seated near Christ who is enthroned and surrounded by a militia of angels.[16] The poet's journey concludes with a description of God, flanked by his Son, and surrounded by a choir of angels, who radiates love to all of creation.

Poet or heretic? Praise for, and condemnation of, the Città di Vita

Palmieri's account of the angelic nature of the human soul derives from Origen (for whom also see pp. 20 and 45), who had studied the philosophies of Plato, the Pythagorians and the Stoics. Origen was among the principal theologians interested in allegorical and 'spiritual' interpretations of the Bible. In his book *On First Principles* (*Peri Archon* in Greek), he discusses the notion of the pre-existence of souls, the identification of humans with the angels who remained neutral during the rebellion of Lucifer, the universal redemption of all of the souls and the fundamental importance of free will.[17] Palmieri was most likely introduced to Origen's ideas by Ambrogio Traversari, Prior of the Camaldolese monastery of Santa Maria degli Angeli (for whom see pp. 20–1).[18] Similarly, scholars such as Marsilio Ficino (1433–1499), a Neoplatonist philosopher and Catholic priest, discussed Origen's ideas in his lectures on the immortality of the soul, where he described the theologian as a '*Platonicus nobilissimus*' (most noble Platonist).[19] This notwithstanding, the Church's position on Origen was less sympathetic, and Palmieri's reiteration of his provocative ideas on the nature of the soul in the *Città di Vita* led to condemnation by some theologians and scholars.

Palmieri reveals his awareness that some may find these notions heretical in the poem itself in the summary title of Book I, X: '*la sybilla mostra che l'opinione gia decta non e contraria alla chiesa christiana*' (the Sibyl demonstrates that the aforementioned opinion is not contrary to the Christian Church). Similarly, it is clear from surviving letters between Palmieri and his good friend and theological advisor Leonardo Dati that both were aware that the poem might elicit criticism. Dati, a canon of Florence Cathedral, a Papal Secretary in Rome and the Bishop of Massa Marittima, was a longtime friend of Palmieri's and wrote both an introduction and commentary to the poem.

In one letter, dated 1464, Dati praises Palmieri's poem and indicates that he will write an accompanying commentary so that he might protect Palmieri from criticism.[20] A letter of 1465 indicates that Dati has sent the commentary to Palmieri, urging him to revise the poem and, although no drafts of the poem survive, in a letter of 1466 Dati thanks Palmieri for sending him a revised copy.[21]

At least five copies of the complete manuscript survive; the deluxe copy of the poem was commissioned by the author himself following Dati's death in 1472 (see fig. 26). This edition includes both the text of the poem and Dati's commentary and may be interpreted as Palmieri's homage to his good friend. It may also represent an act of self-defence commissioned when Dati was no longer able to defend Palmieri in person. This manuscript comprises over 300 pages of vellum, most of which are divided into two columns, with the left containing Palmieri's poem in the vernacular, and the right, Dati's commentary in Latin. It is signed by the copyist Neri di Filippo Rinuccini. The accompanying illuminations by Francesco Botticini (and perhaps the young Gherardo di Giovanni) represent the first collaboration between the patron and artist, establishing a relationship that would eventually culminate in the altarpiece for Palmieri's funerary chapel in San Pier Maggiore.

The Laurenziana manuscript contains three glorious full-page illustrations representing the Universe, Hell and the Mountain of Virtues (see figs 27–9). Each of the three books opens with a delicately illuminated page (see fig. 26). It includes a number of miniatures illustrating constellations and the signs of the zodiac, all executed in vibrant colour and gold leaf (fig. 30). At the end of the poem is a pen and ink portrait of Palmieri in the form of a medallion or an ancient Roman *imago clipeata* (a portrait bust in relief enclosed within a roundel) inscribed with an epitaph (fig. 31). Interestingly, in the epitaph (presumably written by Palmieri), he identifies himself as a writer and poet (rather than an apothecary or statesman) and leaves blank spaces to be completed with the year of his death and the age he died. Palmieri clearly envisaged the work as part of his personal legacy as he asked that the manuscript be placed on his chest at his funeral in San Pier Maggiore, a request that was honoured (according to an inscription at the back of the Laurenziana manuscript). This was a common practice at the funerals of Renaissance humanists. The great historian Leonardo Bruni, for example, had his *History of the Florentine People* placed on his chest at his elaborate public funeral in the church of Santa Croce in 1444. The same inscription in the back of the *Città di Vita* also indicates that this copy of the poem was

Con auriga el pie mostra che si pigli
posinoli al toro infino insu le corna,
che lyacle fanno & fan la testa ĝigli.
Doue la sua figura ad nulla torna
le plyade hanno sepre lumi accesi
che la sua coda delli ariete horna.
Cefeo conle sue mani & membri stesi
le spalle segue della minore orsa
ne tutto uarca negli altrui paesi.
Presso che sempre casiepia corsa
& rierto andromade el cauallo,
che capo & uentre traggon duna borsa.
[43]
Presso ariete in cielo ad questo stallo,
del chero porta conle corna torte
& son tre stelle uanno quasi in ballo.
[44]
Sotto el suo pede epesci stan per sorte,
data da chi cotale ornato pinxe,
[45]
& la lyra e con questa bella corte.
[46]
Luccel con ambe lali in cielo adiunse,
dal tropico maggior di questa uolta
infino al cerchio epie daquario cinxe.
Con piu di queste ymagini sinfolta,
& uolto aquario quasi che supino
fa di sua acqua sopra el pesce colta.
[47]
Da la sinistra mano a capo chino
col sol tramonta capricorno in cielo,
guardando aquario ghe sempre uicino.
[48]
Mostra con questi laquila gran zelo,
coquali & di & nocte saccompagna,
sotto la saeta e formata in cielo.
[49]
Segue el dalphino che nel mar sibagna
per quel che sene mostra ad uostra uista,
quando in leuante uirgo al cieco ragna.
[50]
O non desto spatio aperto acquista,
con diciassepte stelle la sua parte,
ne sol con quelle fa solo una lista.

eo circulo & ita collocate ut
unaqueq̃ earum resupinata
capur alterius tegere uidea
tur ita tamen ut caput eius
que superior est ad caudam
inferioris conuertatur. has ur
sas maiorem & minorem uo
camus. Draco uero celestis cir
culari & dupla sui corporis re
flexione iuxta has duas ursas
ita collocatus esse uidetur ut
corpore sinu facto minorem
ursam ita concludat ut pene
pedes eius tangere uideatur ca
uda autem in alterum sinum re
flexa capud ursae maioris at
tingat ut apparet per figuram
in presenti margine designan
dam. Sed ante q̃ ad particula
res & proprias celestium yma
ginum formationes ueniamus
uniuersas spere stelliferi celi fi
guras collocationesq̃ ponemus
ut manifestius quid auctor in
tellexerit ostendatur. & erunt
hec omnia mente tenenda illis
qui ea que sequuntur recte in
telligere uolunt;

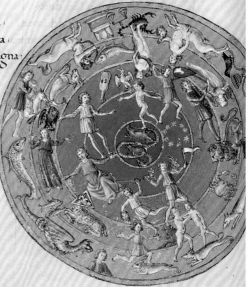

(right)
31
MATTEO PALMIERI (author)
La Città di Vita, about 1473
Vellum manuscript, 38 × 28 cm
Biblioteca Medicea Laurenziana,
Florence (Plut. 40.53, fol. 303r)

Located at the very end of Palmieri's
poem, this pen and ink portrait takes
the form of a medallion or an ancient
Roman *imago clipeata* (a portrait bust
in relief enclosed within a roundel).
It is inscribed in Latin with the virtues:
Fides (Faith), *Religio* (Religion), *Caritas*
(Charity) and *Spes* (Hope) and an epitaph
identifying Palmieri as a writer and poet.
The blank spaces to be filled in with the
year of his death and the age he died
remain incomplete.

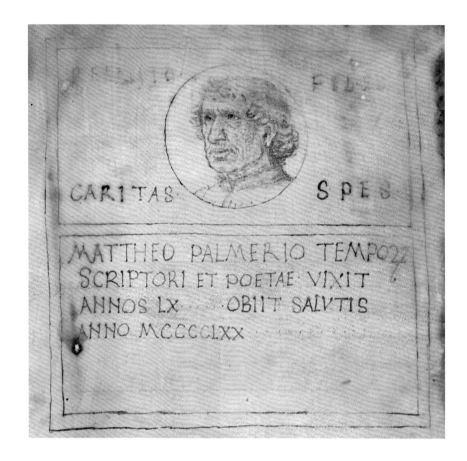

(opposite)
30
MATTEO PALMIERI (author)
La Città di Vita, about 1473
Vellum manuscript, 38 × 28 cm
Biblioteca Medicea Laurenziana,
Florence (Plut. 40.53, fol. 41v)

This illumination accompanies Dati's
notes to the Latin commentary of Book 1,
Chapter 8 of the *Città di Vita*, which
recounts the names and arrangement of
the stars and the images (constellations)
that are formed from them.

sealed and entrusted to the Guild of Notaries by Palmieri on condition it
was not to be opened in his lifetime, a precaution suggesting he already
suspected that his poem might be misinterpreted in the future.

That Palmieri was honoured with a public funeral in recognition of his
services to the Florentine republic (as described in Chapter 1) reveals the
esteem in which he was held at the time of his death. It is clear that his poem
was already circulating shortly thereafter as, for example, Leonardo Benino,
a member of the literary circle that gathered around Lorenzo de' Medici,
wrote a chapter in praise of Palmieri and the *Città di Vita* in 1475.[22]

Allegations of heresy

The first widely disseminated evidence that Palmieri was suspected of
heresy occurs in Cristoforo Landino's commentary on the *Divine Comedy*
(1480) in which Landino, who knew Palmieri well, refers to the accusations
made against him.[23] Several accounts reveal that Palmieri's work was known
beyond Florence by this time and by 1483 a distorted view of Palmieri and
his activities was being disseminated by figures such as Filippo da Bergamo,
an Augustinian monk, who, in his *Supplementum Chronicarum*, implied that
because of the content of the *Città di Vita*, either Palmieri or his poem
(the phrasing is ambiguous) was condemned and burned.[24] Filippo's text

circulated widely and was reprinted several times over the next decade, leading to its reiteration and further distortion.[25] Although he recanted in 1502, the rumours continued nonetheless. Several decades later, in 1549, Giambattista Gelli claimed that Palmieri's bones had been disinterred as a result of his heretical beliefs and, in a later publication, Gelli asserted that the poem had been condemned.[26]

The artist and historian Giorgio Vasari repeats parts of this hearsay in his *Lives of the Artists* in which he praises the beauty of the altarpiece in San Pier Maggiore, indicating that it was Palmieri himself who provided 'Botticelli' (to whom he mistakenly attributes the altarpiece) with the design (*disegno*). The biographer goes on to say that jealous detractors, unable to condemn the work on any other level, claimed that Palmieri and 'Botticelli' were guilty of the sin of heresy, a judgement that, Vasari claims, is not his to make.[27] Vasari, it would seem, was the first to connect the potentially heretical aspects of the poem with the painting, although it should be stressed that nothing in the altarpiece can be specifically identified as unorthodox.

Giuseppe Richa (1693–1761), a Jesuit scholar who wrote a series of volumes on Florentine churches (begun in 1754), dedicates a long section of his chapter on San Pier Maggiore to the Palmieri chapel and to the controversies surrounding Palmieri and his poem. He divides the authors writing on Palmieri into four different groups: those who claim Palmieri was burned alive as a heretic; those who claim his body was disinterred and either burned or relocated elsewhere; those who claim the poem was condemned and/or burned; and those who he claims are closer to the truth, who praise the life and works of Palmieri and remain silent on the subject of his potential heresy.[28]

Given that the altarpiece includes a portrait of Palmieri, which remained visible in the church in his day, Richa countered, why should we believe any tales of the patron's body being disinterred, burned or condemned? He suggests that Dati's support for the *Città di Vita* should suffice as a defence. Richa reveals that the doubts cast on the poem eventually raised suspicion among the priests of San Pier Maggiore, who began to look at the altarpiece in a new light, believing it to represent a new, false hierarchy of angels that had taken human form. Accordingly, they temporarily prohibited entry to the chapel and covered up the painting. It may have been around this time that the portraits of Matteo and his wife were scratched out in a kind of *damnatio memoriae*, a form of dishonour practised from ancient times intended to erase someone from history, either by striking their name from the history

32

FRANCESCO BOTTICINI
Photograph of the figure of Palmieri
in *The Assumption of the Virgin* with his
face scratched out. Taken in 1955 prior
to restoration.

books or desecrating their image (fig. 32). As Richa recounts, however, the
priests of San Pier Maggiore subsequently re-acknowledged the painting's
sanctity and restored access to it.

Botticini's San Pier Maggiore altarpiece

Measuring over two metres high and almost four metres long, Botticini's
panel depicts the reception of the Virgin into the domed sphere of Heaven
above, with the apostles and portraits of the kneeling donors represented in
the terrestrial sphere below. The artist's innovative composition and format
also incorporates accurate town and city views of Fiesole and Florence
at the lower left of the panel, together with more suggestive views of an
imagined, or perhaps, idealised, fortified city at the right (discussed in the
following chapter). While the painting should not be taken as an illustration
of Palmieri's *Città di Vita,* or of the poem's potentially heretical claims, as
has been suggested, the composition is clearly informed by the poem among
other textual and visual sources.[29]

The first contract between Botticini and Palmieri for the altarpiece no longer survives. However, later documentary sources refer to this contract and indicate that the commission initially came from Palmieri who appears to have advised the artist on the subject and composition as Vasari claimed.[30] The mountain represented in the foreground of Botticini's panel evokes the purgatorial 'Mount of Virtues' as described in the *Città di Vita,* while the plateau at its summit recalls the location of Dante's Earthly Paradise more than Palmieri's Elysian Fields, which he describes in the *Città di Vita* as in the realm of the Fixed Stars.[31] Indeed, the composition of Botticini's panel more closely resembles the structure described in Dante's *Divine Comedy* and represented in Dantesque illustrations by artists such as Giovanni di Paolo and Domenico di Michelino (see figs 21 and 22). This structure begins at the top of the panel with the Empyrean Heaven, moving downwards through the Celestial Spheres (as suggested by the concentric circles in varying shades of blue) to the Earthly Paradise located atop the Mount of Purgatory and finally down to the Earth below. In locating Matteo and Niccolosa in the realm normally associated with the Earthly Paradise, Botticini implies that their souls have ascended through Purgatory; that they have been purified and returned to a state of innocence, like Adam and Eve before the Fall.

The dome of Heaven

Traditionally, artists represented the ranks of the elect and of the heavenly host in neat straight rows within the heavenly realm.[32] Botticini, however, stages his Assumption in a perspectival dome, perhaps inspired by Filippo Brunelleschi's recently completed cupola for the Cathedral of Florence. Botticini may also have recalled the heavenly sphere designed and suspended by the Florentine architect from the rafters of the church of San Felice in Piazza, complete with a rotating choir of angels hanging below, for a play celebrating the Annunciation.[33] Brunelleschi's sets were also used for sacred plays of the Ascension, such as one that took place in the Church of Santa Maria del Carmine, described in detail by a visiting Russian Bishop in 1439. This Bishop recounts how the sets, installed on the rood screen of the church, represented Jerusalem at the left, wonderfully decorated with towers and ramparts, and a hilly landscape rising on the right. Above these he describes a wooden structure, painted to resemble the dome of Heaven, with a circular hole cut at its summit, which was veiled in blue and painted with stars. At the appointed time, this veil was apparently lifted to reveal

the actor playing God the Father, raised and suspended by a means of wheels and pulleys, ready to receive his son. Such sacred dramas became exceptionally popular during the fifteenth century in Florence. They were eagerly anticipated events that lived on in the collective memory and provided dramatic inspiration for artists such as Fra Filippo Lippi, Botticini and Botticelli among others.[34]

Botticini's altarpiece is a complex and innovative product of the spiritual, philosophical and artistic context in which it was produced. Visitors granted access to the Palmieri chapel in San Pier Maggiore would have recognised the work as a dramatic presentation of their conception of the Universe with the Earth at its centre, embedded in a series of concentric celestial spheres leading all the way up to the highest heaven, the Empyrean. Most would have been familiar with Dante's *Divine Comedy* and, more specifically, with his descriptions of the Mount of Purgatory and the Earthly Paradise, which they would have also identified in the painting. Contemporary Florentines might have connected Botticini's composition with Domenico di Michelino's panel in the Cathedral, and therefore might have recognised the portrayal of Palmieri as the 'new Dante'. The vast three-dimensional dome of Heaven in Botticini's panel may have reminded them of the dynamic sets designed for the sacred plays that were performed on feast days throughout their city. These dramas brought religious narratives such as the Assumption of the Virgin to life and associated them in the Florentine mind with the urban fabric of their own city. Only those few who knew Palmieri's poem well, and the arguments made against it, would have sought or tried to identify visual parallels between the *Città di Vita* and Botticini's altarpiece. Every Florentine, however, would have recognised the key spiritual and civic sites represented in the lower half of the painting (discussed in the following chapter) and those familiar with Palmieri's life or the popular histories and treatises he wrote (especially *Della Vita Civile*) would have identified how his personal philosophies, such as *l'utilità commune*, and practices such as *magnificenza,* are reflected in the painting and its commission.

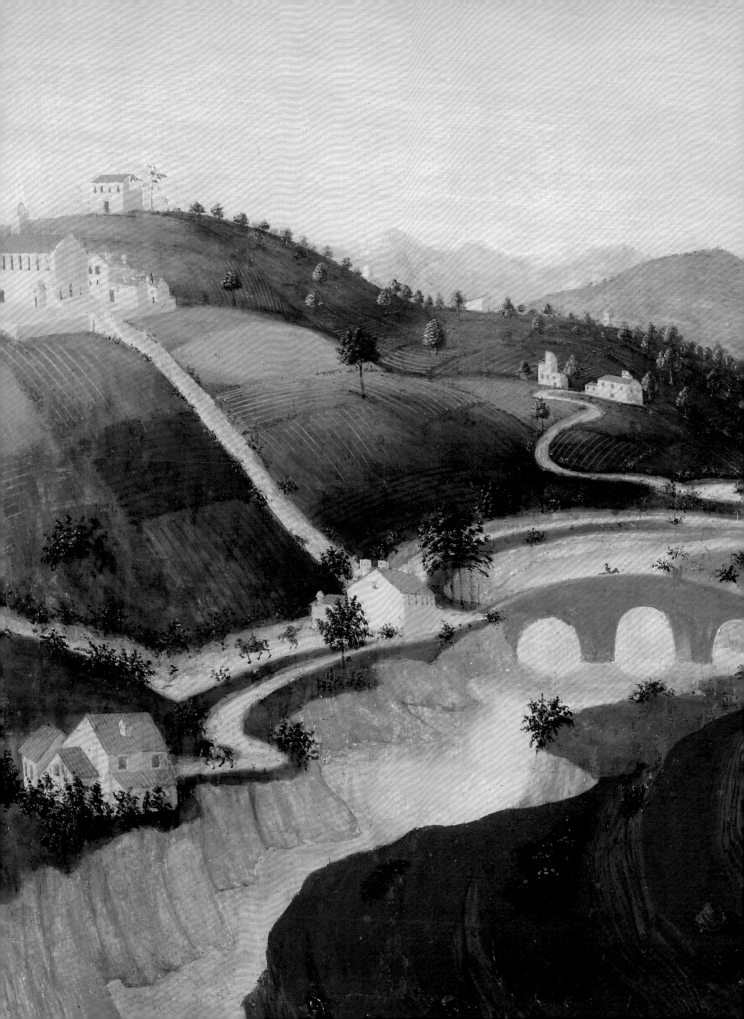

3 The Importance of 'Place' in the Palmieri Altarpiece

The extraordinary panoramic landscape in Botticini's Palmieri altarpiece is one of the earliest naturalistic and topographically accurate painted views in Italian art. Landscape painting as an independent pictorial form did not yet exist in this period and the genre would only begin to develop in the following century. Identifiable portrait-landscape types, however, were evident in the backgrounds of history paintings from the Netherlands and began appearing in works by Florentine artists such as Alesso Baldovinetti, Biagio d'Antonio and the Pollaiuolo brothers from the 1460s onwards.[1] These artists favoured a distant view, usually as seen from a high terrace and often of the Arno valley. The Pollaiuolo brothers' *Martyrdom of Saint Sebastian* of around 1475, for example, is set within a vast receding landscape, relocating an event that took place in ancient Rome to the banks of the winding Arno river (figs 34 and 46).

In Botticini's altarpiece, the high plateau occupied by the patrons and apostles serves as a neat pictorial device which also places the beholder at a height from which to look down and across the artist's fluid panoramic landscape. The view brings together two categories that we might now term the cartographic and the painterly; categories that were hardly distinguished at the time but which were experiencing fundamental developments and advances during precisely this period.

Renaissance maps and city views

The distinction between a map or city view and a landscape painting is neatly summed up by Svetlana Alpers:

> maps give us the measure of a place and the relationship between places, quantifiable data, while landscape pictures are evocative, and aim rather to give us the quality of a place or of the viewer's sense of it. One is closer to science, the other to art.[2]

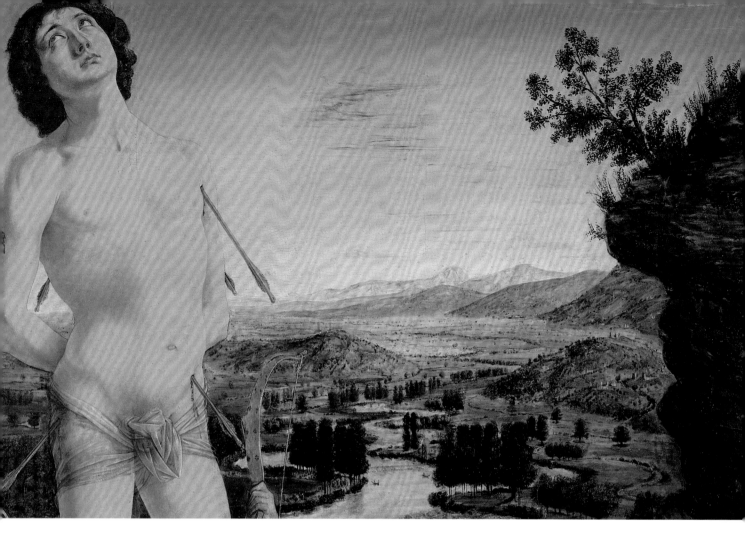

34
ANTONIO and PIERO DEL POLLAIUOLO
Landscape detail from *The Martyrdom
of Saint Sebastian*, completed 1475
Oil on wood, 291.5 × 202.6 cm
The National Gallery, London
See also fig. 46.

These categories, at least as we understand them today, were not so
clearly defined in the fifteenth century and city views often combined
both functions. For example, in the second half of the century, a new
genre of cartography showing town views was just emerging. The earliest
of these were executed by the Florentine painter Piero del Massaio who,
between 1469 and about 1475, produced updated and enhanced views of
Italian and Mediterranean cities (including Florence) for the codices of one
of the greatest ancient geographical texts, Claudius Ptolemy's *Geography*
(written around 150 AD) (fig. 35).[3] These bird's-eye views represent the
walls enclosing each city in an idealised, somewhat schematic manner
while the buildings represented within them provide a more naturalistic
urban portrait. In composing these views, Piero uses a 'non-systematic
perspective', that is, he shows multiple sides of a building at the same
time, using several different vanishing points and a slightly raised point of
observation to create the sense of recession into space.[4] Piero included only
the most significant and iconic landmarks of a city in his views, such as
rivers with bridges, main roads, and buildings that were the seat of political,
religious, or civic power. This approach to mapmaking enabled him to
give particular attention to specific monuments without sacrificing the
harmonious appearance of the overall view.

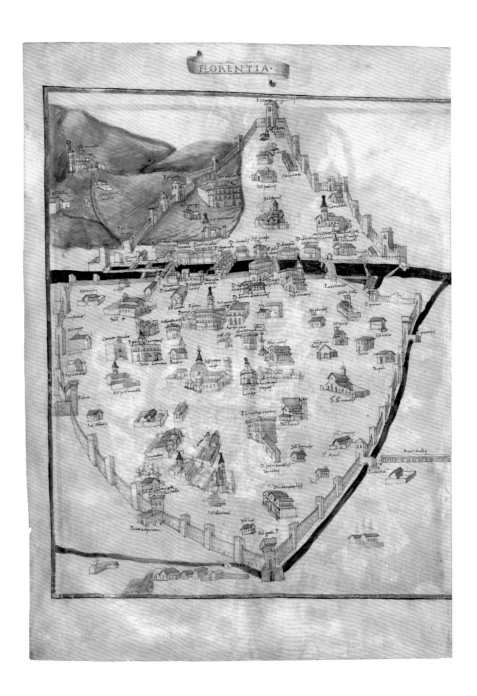

35

PIERO DEL MASSAIO
Map of Florence, 1473 (right), with detail
of San Pier Maggiore (below, centre).
Biblioteca Vaticana, Vatican City
(Vat. Urb. Lat. 277, fol. 130v)

In his *Florentia* map of 1473 for example, Piero includes the fortified
walls of Florence and, near the centre, the major landmarks of the Duomo,
Baptistery, Badia Fiorentina and Palazzo Vecchio among others. He also
includes a 'portrait' of San Pier Maggiore and its campanile, here shown
to the left of the Cathedral, a testament to the church's importance in
the period. Piero's city views are distinctive for the recognisability of the
monuments, regardless of their manipulated perspective and the fact that
the artist eliminated much of the urban fabric located in between major
buildings. Piero's views correctly position major monuments in relation to
each other and, in this way, draw out spatial relationships and alignments
between key buildings, revealing the axes of power.

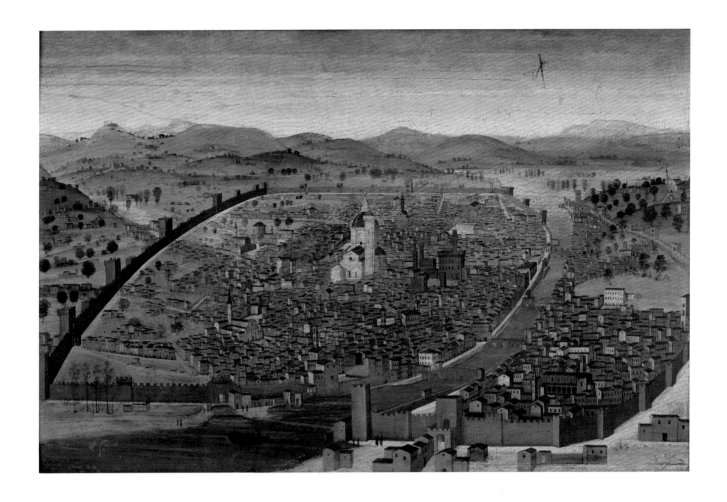

36
Workshop of
FRANCESCO DI LORENZO ROSSELLI
View of Florence, around 1500
Oil on panel, 95.2 × 143.5 cm
Private collection

Shortly after Piero made the *Florentia* map, another Florentine artist, Francesco Rosselli, was creating what was to become the most famous city portrait of this period. His view, known as the *Map of Florence with a Chain* or the 'Chain Map' (because of its frame in the form of a chain and padlock) exists in at least three versions: the original engraving of around 1480–2 by Rosselli of which only one sheet survives, a later faithful woodcut copy of the engraving attributed to Lucantonio degli Uberti (see fig. 23) usually dated to the 1490s but sometimes as late as 1510, and a painting of around 1500 by Rosselli's workshop (fig. 36). The 'Chain Map' shows the city from the hills to the south west and was probably a composite view taken from different viewpoints. This perspectival view provides a fairly accurate impression of the city, establishing reasonably exact relations of size between the various buildings and the surrounding walls. Unlike Piero's city view, the 'Chain Map' includes details of the urban fabric, such as the palaces of wealthy merchants and numerous villas in the surrounding countryside, all placed with a high degree of precision within an extended topographical representation. This view is clearly a celebration of the beauty, power and wealth of Florence and is the type of image that important figures such as the Medici rulers and their supporters could use to help establish the reputation and credibility of the city in the eyes of foreign politicians

and merchants.[5] Indeed, ambassadors and designated messengers would often travel to foreign cities with such city views and, increasingly, with detailed and specialised maps that were being produced to support more administrative and military functions.[6] Palmieri himself may have carried such maps when serving as Florentine ambassador to several different cities (as discussed in Chapter 1).

Botticini painted his panoramic view just a few years after Piero began producing his city views and his landscape appears to draw on these early visual sources. In some ways, it anticipates later Florentine maps that combine axonometric (a three-dimensional projection revealing multiple sides of a building) and perspective techniques, such as Rosselli's and that made by the Medici's cosmographer, Stefano Buonsignori in 1584 (fig. 37). The landscape in the Palmieri altarpiece is made up of several 'places' that this chapter explores in depth: the district of Fiesole at the far left of the panel, the city of Florence just left of the centre, the raised plateau (identified as the Earthly Paradise in Chapter 2) occupying the middle of the composition, and, at the far right, a second, as-yet-unidentified, river valley and fortified city.

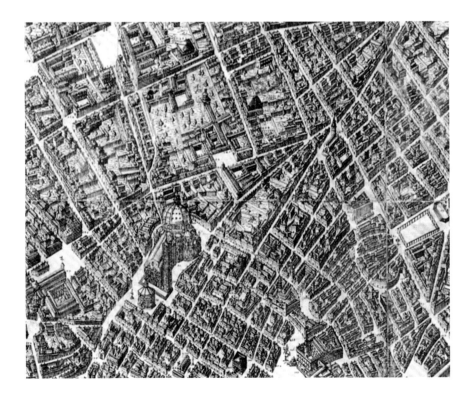

37
STEFANO BUONSIGNORI
Detail of eastern part of map of Florence, 1584.
Engraving
Museo Storico Topografico di Firenze com'era, Florence

Botticini's panoramic view

The broad panorama that serves as a backdrop for Botticini's *Assumption of the Virgin* represents the Arno valley as seen from the hills north east of Florence (more precisely, from Monterinaldi) and accurately represents the profiles of the surrounding hills and mountains. These include, from left to right, the hill in the area of San Domenico in Fiesole with the Apennines and, beyond them, Monte Moro in the far distance. To the right are the Monte Morello, the Calvana and the Pistoian Mountains.[7] The portrait of Palmieri is neatly located mid-way between the two places where the merchant-statesman-humanist split most of his time, the hill of Fiesole and the city of Florence. The portrait of his wife, Niccolosa de' Serragli, situated opposite, mirrors her husband's in location and pose. She kneels before another river valley populated by a far less identifiable city enclosed by fortified walls. While Botticini never produced another work on this scale, or a panoramic landscape so intimately associated with the lives of his patrons, he did re-use parts of these views in at least two of his other paintings, suggesting that he was particularly pleased with their effect (fig. 38).[8]

Fiesole

The hill at the far left of the panel is in the district of Fiesole, easily distinguished by its famous old abbey, known as the Badia Fiesolana, which still survives today, surrounded by several other buildings that made up the monastic complex (fig. 33). According to tradition, this abbey church was built on the site of an oratory founded by Saint Romolo (Romulus of Fiesole, died 90 AD), considered the first bishop of Fiesole and a disciple of Saint Peter to whom he dedicated the church.[9] The building was later expanded to serve as the Cathedral of Fiesole until the eleventh century, when the Cathedral had outgrown the site and was re-established in a new location higher up the hill (where it stands to this day). The old building was then converted into a Benedictine abbey until the 1440s, when the Pope transferred the church to the Augustinian monks. In 1456, Cosimo de' Medici took over the patronage of the Badia and set about expanding and redecorating the church and adjacent monastic complex, adding a great scholarly library.[10] Demonstrating his high esteem for the humanist-statesman, Cosimo gave Palmieri the patronal rights to the third chapel in the left aisle of the Badia that was dedicated to Saint Francis.[11] It has been

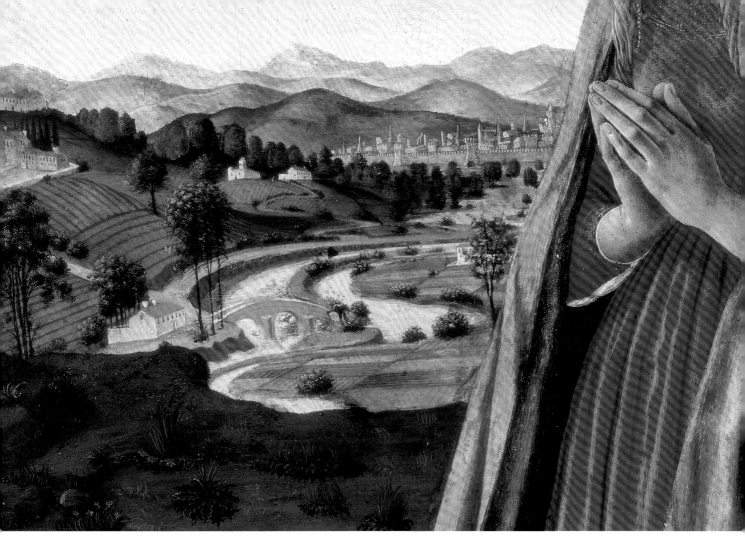

38

FRANCESCO BOTTICINI
Landscape detail from *The Virgin
adoring the Christ Child*, showing
Fiesole and Florence, about 1475–80.
Tempera on wood, diameter 105 cm
Collezione Credito Bergamasco –
Gruppo Banco Popolare, Bergamo
See also fig. 51.

suggested that Botticini's altarpiece, commissioned for Palmieri's funerary
chapel, was originally painted for the Badia in Fiesole and not San Pier
Maggiore, as the rights to the Florentine chapel were only finally secured
after his death.[12] Although possible, there are several reasons to think this
was not the case, firstly because Palmieri's many wills all state his desire
to be buried in San Pier Maggiore. Secondly, the subject of the altarpiece
does not reflect the dedication of the altar to Saint Francis, and the adjacent
chapel in the Badia, owned by the Gaddi family, was already adorned with
an altarpiece of the Assumption, making it unlikely that Palmieri would
commission an altarpiece of the same subject for his chapel.[13] Nonetheless,
the Fiesole church and chapel would have held both spiritual and social
significance for Palmieri. One of the primary religious buildings in Fiesole,
the Abbey was second only to the Cathedral in importance and it is
interesting to note that Botticini crops his composition at the Badia, thus
omitting the Cathedral beyond.[14] By the 1470s, the Badia had also become
a site deeply connected with the Medici, whose coat of arms proliferates
in the church and adjacent monastic buildings, and with the academic
circles that met there due to the presence of Cosimo de' Medici's library.
The straight road descending the hill from the Badia to the Mugnone river

FRANCESCO BOTTICINI
Detail from *The Assumption of the Virgin*, showing Palmieri's *podere* and villa.

and bridge, known as the Ponte alla Badia, survives to this day. While only part of the path following the river on the Badia side remains, the road on the opposite side of the river, the Via Faentina, still survives.

The two prominent buildings on the hill below the Badia are also closely associated with Palmieri (fig. 39).[15] Accessed by the old Via Fiesolana, these buildings must represent the *podere* (farm) and villa that Palmieri acquired in the area known as Schifanoia (literally 'to chase away boredom', a term implying a certain carefreeness) on the slopes of Fiesole in 1454.[16] In comparing the appearance of these buildings and their locations in the painting with the surviving structures today, it is clear that both have been substantially transformed and expanded over the centuries. However, the building on the left, which is located slightly further up the hill, must have been the *podere* (today the Villa del Cancellino), while the lower building occupies the site of the current Villa Palmieri.

The *podere* at Schifanoia was one of several owned by Palmieri (the other farms were primarily located in the Mugello valley region north of Florence). These served as a great source of both food and revenue, as they were rented out to farmers who paid Palmieri a steady income. Palmieri clearly felt that farms and farming were a crucial part of a healthy and flourishing city; as he devotes a section of *Della Vita Civile* to a discussion of the 'usefulness' of crops, livestock, servants and labourers as key sources of a kind of individual wealth that also benefits society at large.

The villa acquired by Palmieri was built much earlier, in the fourteenth century, by the noble Fini family and was subsequently owned by the Solosmei from whom Palmieri acquired it. The building had long been known as the Villa della Fonte ai Tre Visi (Villa of the Fountain with Three Faces), presumably after a distinctive fountain located in its garden, and was one of the oldest villas belonging to the Florentine elite in that area. Perhaps unsurprisingly, Palmieri purchased the villa shortly after Giovanni

de' Medici (the son of Cosimo and brother of Matteo's good friend Piero) bought the site for his new villa nearby.[17]

The slopes of Fiesole had long been considered an ideal setting for Florentine country houses. During the hot summer months, Florentines left behind the humid and stagnant air of the Arno river basin and took refuge in the hills above the city, cooling themselves in the shade of the cypress and ilex trees that dotted their terraced villa gardens. Both villa and garden were often designed to afford spectacular panoramic views over Florence, its valley, and the surrounding hills. A villa provided a place to cool off in the summer months as well as somewhere to enjoy *otium*, a Latin term used by the ancient Roman statesman and scholar Pliny the Younger (around 61–112 AD) to describe the leisure activities he pursued in his villas, which included elaborate dinner parties and festivities but also quiet time to read and write undisturbed.[18] Pliny's *Letters* were particularly popular with Renaissance humanists and architects who absorbed the ancient author's lessons on the restorative powers of the natural villa setting in contrast to the stressful effects of daily business conducted in the city (*negotium*).[19] While the ideal villa lifestyle afforded peace and rest, it was also meant to encourage artistically valuable or enlightening activities. According to Pliny, the cultural life of poetry, art, and letters unfolded in a setting apart from the urban experience.

The Villa della Fonte ai Tre Visi (later the Villa Palmieri) has a long history of association with the setting for Boccaccio's *Decameron*.[20] Boccaccio describes how his young protagonists retreated from the Black Death then raging in Florence to a villa overlooking the city, where they recounted a series of tales. In the introduction to the Third Day of the *Decameron* Boccaccio describes the villa garden:

> To see this garden, its handsome ordering, the plants, and the fountain with rivulets issuing from it, was so pleasing to each lady and the three young men that all began to affirm that, if Paradise could be made on earth, they couldn't conceive a form other than that of this garden that might be given it.[21]

The *Decameron* was a book Palmieri knew well and, as described in Chapter 1, it directly inspired the structure of his own *Della Vita Civile*, which similarly takes the form of a series of dialogues in a villa outside of Florence where the interlocutors have taken refuge from the plague of 1430.

Certainly by the time Boccaccio wrote the *Decameron,* if not before, Fiesole had become a *locus amoenus,* that is, an idyllic place of pleasure and beauty often associated with Eden or Elysium.[22] This tradition was perpetuated through the fifteenth century in the letters and the pastoral poems of famous Florentine humanists such as Angelo Ambrogini, known as Poliziano, and Marsilio Ficino.[23] Although written a few years after Botticini's painting, Ficino's famous letter to Filippo Valori of 1488 evokes a similar atmosphere. Ficino, who knew Matteo Palmieri personally, describes a walk across the lower slopes of Fiesole with the philosopher Pico della Mirandola, during which they imagine an ideally situated villa. Coincidentally, they then come across such a house, at which point Pico exclaims:

> O fortunate man, whose lot it is to live in a sacred temple when
> he withdraws from public affairs: a temple, I say, for it has been
> placed near this sacred grove and twenty temples of the gods
> surround it. And so the place is holy above all others and especially
> suited to oracles.[24]

In likening villas to sacred temples and their inhabitants, presumably enlightened scholars or patrons, to gods, Pico reveals how Fiesole held a very special place in the Florentine imagination of this period; a paradisiacal place of refuge that invited discussion, profound study and spiritual contemplation.

Botticini, like Piero del Massaio, includes only select monuments in his representation of Fiesole and omits lesser buildings that do not specifically help locate or situate the key buildings in relation to each other. He is careful to articulate relevant roads and bridges and a few buildings to provide a sense of scale and perspective but otherwise leaves the slopes relatively bare. While the area was certainly less developed than it appears today, documentary sources indicate that it was more populated than this stripped-back representation would suggest.[25] For this reason, the additional, and rather prominent villa visible above Palmieri's villa and *podere,* situated on the crest of the hill in the area of Camerata, appears significant. Distinguished by an upper level loggia, known as a *verone,* it has been argued that the house represents Villa delle Lune, purportedly built by the politician and historian Bartolomeo Scala.[26] However, Villa delle Lune was built in the mid-1480s and thus postdates the completion of Botticini's altarpiece by several years. Evidence suggests, however, that Scala's villa was built, probably according to the designs of the famous Florentine architect Giuliano da Sangallo,

on the site of an earlier, unknown, villa and it is possible that Botticini intended to represent that building.[27] Certainly, the prominence of the house in this part of the painting suggests it or its owners had a particular importance for Palmieri and it is possible that it represents one of the Alessandri villas in this area, such as the Villa il Monte at Camerata that belonged to Alessandro degli Alessandri, a friend of Palmieri's and the dedicatee of *Della Vita Civile*.[28] While the precise identity of the villa at Camerata remains unknown, it is clear that Botticini was instructed to include key spiritual, agricultural and domestic buildings that had specific meanings for Palmieri and his heirs. The recognisable landscape of Fiesole and its buildings, together with the inclusion of Palmieri's own properties, provide a more personal visual counterpart to the sense of place so eloquently expressed in contemporary Florentine texts such as those by Boccaccio, Ficino and Poliziano described above. Accordingly, the evocation of Fiesole in Palmieri's altarpiece is simultaneously a *locus amoenus* or a paradise garden as described in Boccaccio's *Decameron,* and a kind of dynastic appropriation of a whole district of the countryside.

Florence

Around the same time as the poetic and evocative texts describing Fiesole were being circulated, an even greater number of texts were being written by Florentine humanists on their beloved native city and its virtues. Leonardo Bruni, for example, extolled the beauty and glory of the city in his *Laudatio Urbis Florentinae* of around 1404–5 and his later *History of the Florentine People* (published 1442), paving the way for authors like Palmieri himself, whose *Della Vita Civile* outlines the qualities of an ideal citizen and praises the moral and political superiority and good government of the city. These kinds of texts, coinciding with the development of new mapping techniques, find analogy in the inclusion of views of Florence in the backgrounds of paintings. Artists such as Biagio d'Antonio, Jacopo Sellaio, Cosimo Rosselli and Alesso Baldovinetti all begin situating key religious episodes such as the Annunciation and the Nativity against the backdrop of Renaissance Florence. The benefit of incorporating recognisable monuments and sites was that it enabled viewers to imagine these sacred events as if unfolding in their own time and before their very eyes, a meditative practice promoted by preachers and in contemporary prayer books. Many of these paintings include the recognisable profiles of the dome

FRANCESCO BOTTICINI
Detail from *The Assumption of the Virgin*,
showing Palmieri kneeling before a view
of the city of Florence.

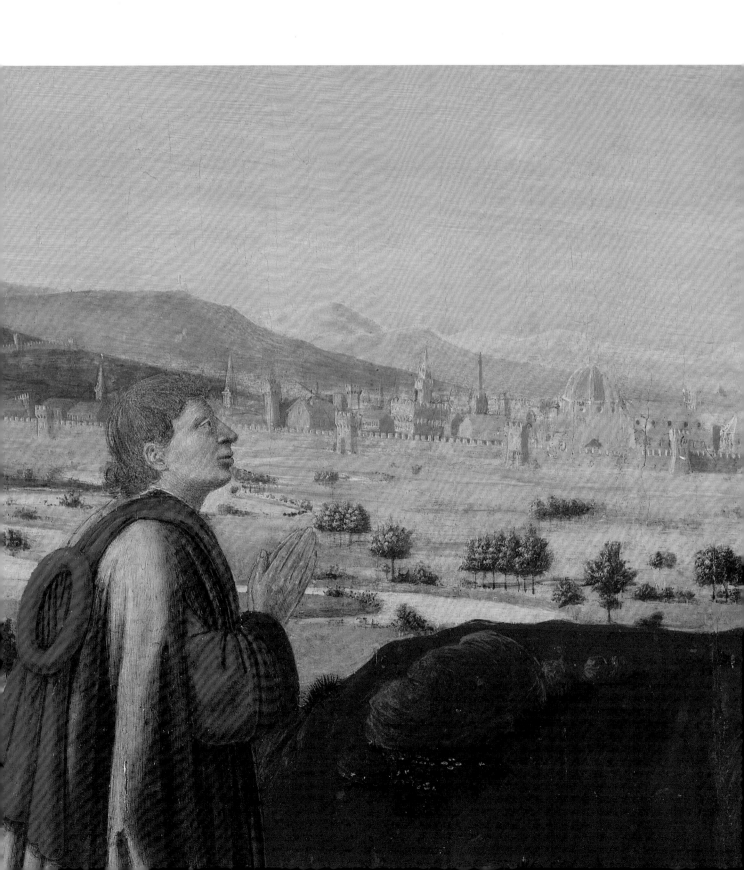

of the Cathedral, its campanile and the tower of the Palazzo della Signoria, as a kind of synecdoche or shorthand for the whole city. Others specifically highlight a particular monument such as the Baptistery and the role it played in a specific event, for example the celebrations of the feast day of Florence's patron saint, John the Baptist.[29]

Although viewed from the opposite side of the city, Botticini's representation of Florence (fig. 40) has much in common with those produced by Rosselli and his workshop. Like Rosselli, Botticini carefully describes the fortified and crenellated walls of the city and several of their monumental gateways. Since the twelfth century, the city's leaders had girdled Florence with walls fortified with towers to provide protection against potential invaders (see fig. 23). These city walls were expanded to accommodate the growing city several times over the centuries and were pierced at intervals with great gates, several of which are preserved. The gate immediately behind Palmieri's head, for example, seems to mark the site of the Porta alla Croce (now in Piazza Beccaria), while just in front of him must be the no-longer extant Porta a Pinti, also known as the Porta Fiesolana, that was destroyed in 1865 and is now the site of Piazzale Donatello. The next gate to the right (moving westwards) no longer survives, while the position of the following gate, at right angles to the city walls, is identifiable as the Porta San Gallo, still visible in Piazza Libertà today. The following gate, Porta Faenza, was incorporated into the Fortezza da Basso in the sixteenth century. The attention given to the representation and shape of the walls and the key entry points into Florence reinforce the sense of the city's strength and security. In addition to controlling regular traffic in and out, the gates were where esteemed visitors to the city, such as visiting pontiffs, princes and ambassadors, would be met with great fanfare and processed into the city.

Inside this fortified ring of walls, the Duomo stands out most prominently with its distinctive pink-tiled cupola, radiating chapels and round windows piercing the drum of the dome and nave. Palmieri, who was born at the beginning of the century, would have witnessed the rising form of Brunelleschi's cupola taking shape during the 1420s and 1430s, in the years he was composing *Della Vita Civile*. He was already climbing the ranks of the Florentine government by the time Michelozzo Michelozzi's lantern was completed in 1461 and Verrocchio's golden ball installed at its summit in 1471. These were proud moments in Florentine history, as the Cathedral, the city's spiritual heart, together with the Baptistery located just in front of it, played a formative role in the life of every citizen. The Baptistery was the

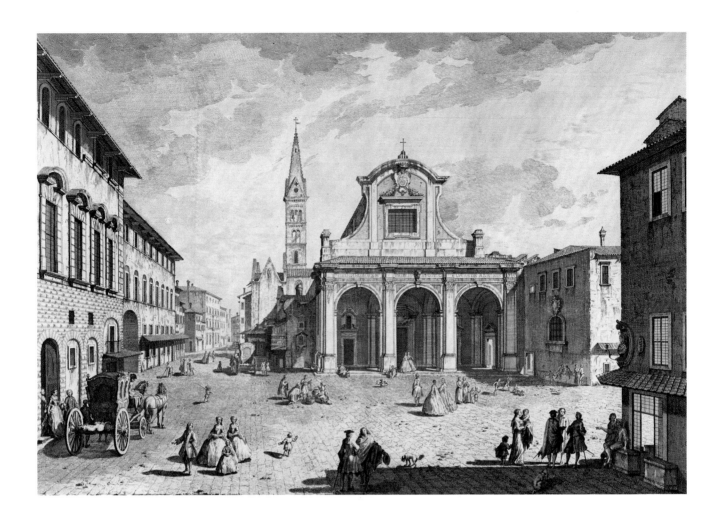

41

GIUSEPPE ZOCCHI
*View of the Church and Piazza
of San Pier Maggiore*, 1744
Album, etching with engraving,
62.5 × 80 cm
The British Museum, London

primary site of civic and religious self-identification as it served as the site of baptism for the entire city until the late nineteenth century: it was through this ritual that one became simultaneously a Christian and a Florentine citizen. Located opposite the Cathedral and Baptistery on the east–west axis stands the city hall, the Palazzo della Signoria (later known as the Palazzo Vecchio), distinguished by its high, fortified walls and tall crenellated tower, purposely built higher than any other tower in the city. This massive fourteenth-century fortress-palace was named after the ruling body of the Republic of Florence (the *Signoria*) and the building still serves as the seat of the city council today. This building would have held personal importance for Palmieri who held office in the Florentine government almost every year from 1431 until his death in 1475 (see pp. 22–4).

Moving eastwards (or to the left) across Botticini's cityscape are two more identifiable monuments. Although the painting is somewhat worn in this area, one can discern a pointed spire and, just to the left, a slightly lower, crenellated tower in close proximity. These would seem to correspond with the spire of the Badia Fiorentina and the campanile of the Bargello located just across the street. The Badia, like San Pier Maggiore, was a Benedictine institution and was founded in the tenth century. It acquired its tall bell

tower in the fourteenth century, an addition that soon became a distinctive part of the city skyline. In addition to marking religious feasts and the times of day, the Badia bells were rung to signal both warnings and celebrations, and especially to commemorate military victories to the whole of Florence, thus playing a central role in Florence's civic consciousness.

The Palazzo del Bargello is the oldest public building in Florence and was built in the mid-thirteenth century to house the *Capitano del Popolo* (Captain of the People), a member of the wealthy merchant class elected to represent the populace. The building subsequently housed the *Podestà*, the highest magistrate of the Florence city council, until 1574 when the Medici dispensed with the function and gave it to the *bargello*, the chief of police, from whom it acquired its current name.

Finally, the large spire located just above Palmieri's nose must belong to San Pier Maggiore, the church for which this altarpiece was made (fig. 41, and see fig. 5). The Benedictine convent church of San Pier Maggiore (destroyed in 1784) was one of the oldest, wealthiest and most venerated religious institutions in Florence. According to tradition, a church founded by Saint Zenobius, Florence's first bishop, had existed on the site since the fifth century. The convent is only first officially recorded, however, in 1067 when Ghisla Firidolfi is named as its first abbess.[30] The church was re-founded as a Benedictine convent and in the early fourteenth century was substantially renovated and enlarged. Despite subsequent additions over the centuries, the structure retained much of its Gothic architectural character until the eighteenth century. When one of the gothic columns of the church crumbled in 1783, it was feared that the entire structure might become unsound. Unfortunately, in the course of renovation, part of the church crumbled and the convent was hastily declared unsafe by the Grand Duke

Pietro Leopoldo, who ordered its destruction. Today, little more than the three arches of Matteo Nigetti's seventeenth-century portico-façade survive (fig. 42).

Following the convent's demolition in 1784, the nuns were relocated to a neighbouring oratory belonging to the Servite church of the Annunziata and the relics, liturgical furniture and artworks of the convent were similarly redistributed among different religious institutions, or returned to the families who had originally commissioned them. Among these precious objects were two monumental altarpieces that eventually made their way into the collection of the National Gallery, London: a fourteenth-century polyptych (a multi-panelled altarpiece) by Jacopo di Cione and his workshop, and Botticini's *Assumption*.

Florence as the 'New Jerusalem'

That the city of Florence serves as a backdrop for the Virgin's Assumption suggests it was also intended as an evocation of the Holy City, as Jerusalem was traditionally believed to be the site of the Virgin's death (or Dormition) and Assumption. While the Assumption of the Virgin is not recounted in the Gospels, later apocryphal tales elaborate on Mary's passing, describing how, at the moment of her death, the apostles, who were all preaching in different parts of the world, were miraculously transported to her deathbed at Jerusalem. According to the popular *Golden Legend*, a compendium of saints' lives written in the thirteenth century by Jacobus de Voragine, the Virgin died in the Valley of Jehoshaphat, a place identified by Saint Jerome among others as the Kidron Valley, located on the eastern side of the Old City of Jerusalem. In situating the Virgin's Assumption against the backdrop of Florence and the Tuscan Hills, Botticini draws on a long Florentine tradition of identifying itself as the 'New Jerusalem'.[31]

Florence, like several other cities, liked to portray itself as the New Jerusalem through texts, images, architecture and relics that drew parallels between the two cities. The New Jerusalem, according to the Book of Ezekiel, a major prophetic book in the Old Testament, would consist of a renewal of the Old City and the rebuilding of the Holy Temple during the Messianic era (Ezekiel 40). In the Book of Revelation in the New Testament, however, the New Jerusalem is also described as the 'Heavenly Jerusalem' believed to be established when Christ reigns over the saints (Revelation 21). In Revelation, John of Patmos describes how an angel took him 'in the Spirit'

to a vantage point on 'a great and high mountain' to see the New Jerusalem's descent from heaven down to the Earth, where the river of the Water of Life flowed, and much of his elaborate description evokes the garden of Paradise (Eden) (Revelation 21–22).

In casting Florence as the historic city of Jerusalem and as an evocation of the New Jerusalem, that is, the Heavenly city to come, Botticini was making a special claim for his native city and its citizens, associating them with the elect who will populate the eschatalogical kingdom.

An unidentified fortified city

On the right-hand side of Botticini's panel is a second river valley whose waterway emerges from behind the mount in the foreground and curves back into the distance, flowing towards a fortified city that is bordered by hills and a mountain chain on the far right. While it has been suggested that the slopes dotted with farms behind Palmieri's wife, Niccolosa, reflect properties she brought to the marriage as part of her dowry in the Val d'Elsa, south of the Arno, we now know that Palmieri had sold these properties some decades before commissioning this altarpiece, making this identification highly unlikely.[32] The fortified city immediately before Niccolosa has also been tentatively identified as nearby Prato, given that city's relative proximity to Florence and its preservation of the relic of the girdle the Virgin is said to have given to Saint Thomas at her Assumption (fig. 11).[33] Sadly, the worn condition of the painting in this area makes the city especially difficult to identify, as there are no recognisable towers or monuments to help situate the beholder. In such circumstances, it is often helpful to examine a painting using infrared reflectography, an advanced technology that is used to look through the surface paint to try to reveal earlier stages of the production of paintings such as preparatory studies made directly on to the prepared panel to guide the painter (and his assistants).

Fortunately, Botticini used a great deal of underdrawing throughout the Palmieri altarpiece. These underdrawings were recently made visible through infrared reflectograms of the painting, revealing a surprising series of changes made in the area in question (fig. 43). Botticini changed the location of the city three times. It was drawn immediately to the right of the apostles in one configuration, then behind Niccolosa de' Serragli in another, before being relocated a third time to its present position directly in front of Niccolosa. Botticini appears to have kept the winding form of the earlier

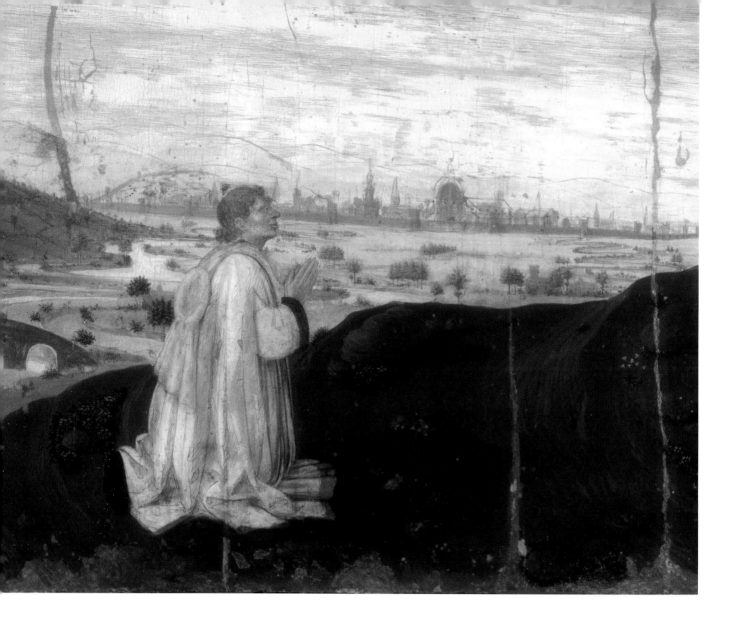

(above and opposite)

43

Infrared reflectograms
showing underdrawings of
The Assumption of the Virgin,
revealing old damages to the
panel including a candle burn.

riverbed and transformed it into the road we now see behind the apostles. These changes indicate that the artist was still deciding on the location of the second city and its relation to the donor until quite late in the design stages of the altarpiece. Markedly unlike the precision of the drawings revealed beneath the painted city of Florence, the summarily sketched drawings of the unidentified city on the right provide no further insight into its identity (fig. 43). Interestingly, the city, as painted in its final location, has no detectable underdrawing, suggesting it was either underdrawn in a different medium or that it was executed in a more spontaneous and fanciful manner. While the landscape remains unidentified, this new information implies there may have been a different motivation for including this second fortified city, suggesting it was not subject to the same topographic treatment as the left-hand side of the panel.

Botticini's panoramic landscape therefore appears to be a sophisticated combination of the cartographic, the naturalistic, the poetic and the spiritual. He fluidly combines views of the district of Fiesole, Florence and the Earthly

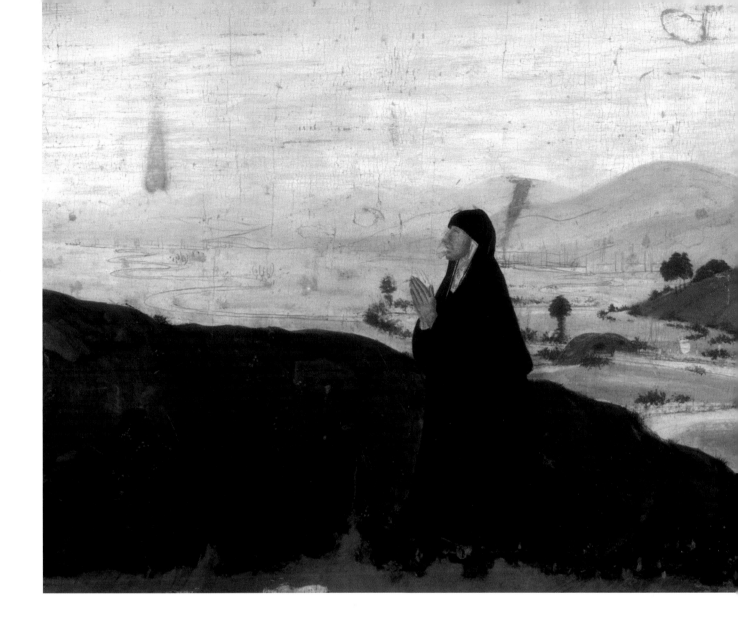

Paradise with the dome of Heaven above, simultaneously evoking the *locus amoenus*, a thriving ideal city, the Holy City and the abode of the Blessed before their journey to Heaven. Read against both Dante and Palmieri's poetic accounts of the soul's journey towards the Empyrean Heaven, the two rivers painted by Botticini on either side of the central mount also take on a second, symbolic, meaning. These recall the Lethe and Eunoë rivers from which souls are bid to drink, the first causing them to forget the memories of their mortal sins or angelic origins, the second strengthening the memories of their good deeds so that their souls may enter Heaven.

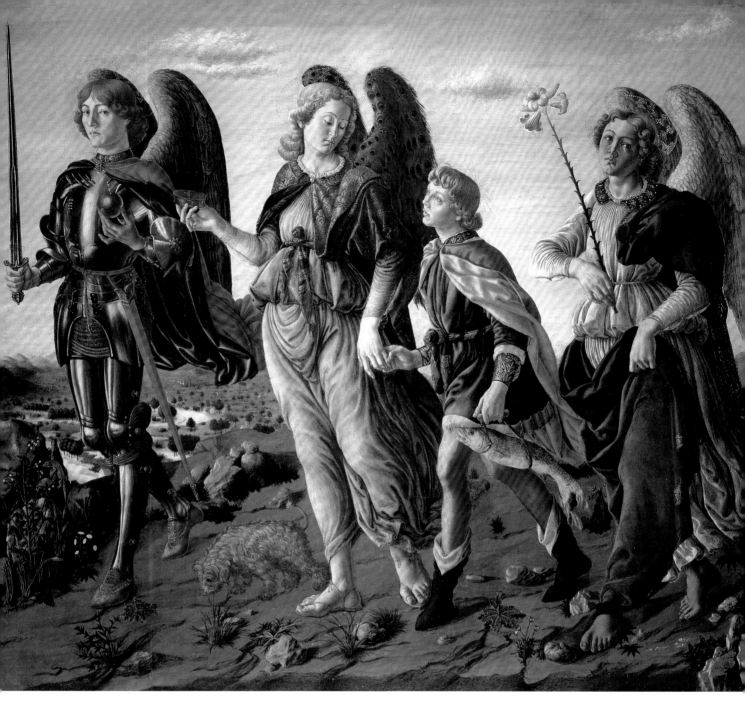

4

(Mis)Identifying Botticini: Style and Attribution

The artist and biographer Giorgio Vasari (1511–1574) mistakenly praised the Palmieri altarpiece as a masterpiece by Sandro Botticelli (about 1445–1510) when viewing the work in its original location around 1550. In his *Life of Botticelli*, he describes how:

> Near the side-door of San Pietro Maggiore, for Matteo Palmieri, he painted a panel with an infinite number of figures – namely, the Assumption of Our Lady, with the Zones of Heaven as they are represented, and the Patriarchs, the Prophets, the Apostles, the Evangelists, the Martyrs, the Confessors, the Doctors, the Virgins, and the Hierarchies; all from the design given to him by Matteo, who was a learned and able man. This work he painted with mastery and consummate diligence; and at the foot is a portrait of Matteo on his knees, with that of his wife... the figures painted therein by Sandro are truly worthy of praise, by reason of the pains that he took in drawing the zones of Heaven and in the distribution of figures, angels, foreshortenings, and views, all varied in diverse ways, the whole being executed with good design.[1]

While Vasari's attribution of the altarpiece to one of the most famous painters in Renaissance Florence was incorrect, his first-hand account is nevertheless helpful in many ways. His high praise for the work and the esteem in which he held it indicates a great deal about its quality. Further, Vasari's account of the work *in situ* helps us locate the altarpiece in a chapel situated in the south transept, that is, the right arm of the cruciform shaped church, where surviving floor plans indicate that there was a side-door (see fig. 17). Vasari also provides us with the identities of the portraits of the patrons, and reveals that Palmieri provided the artist with the design. Given Vasari's importance for the history of art (he is considered by many to be the first art historian) and as a great source of information about Florentine artists in particular, it is perhaps unsurprising that his misattribution of the Palmieri altarpiece remained unchallenged for well over 300 years.

44
FRANCESCO BOTTICINI
The Three Archangels with Tobias,
about 1471–2
Tempera on wood, 135 × 154 cm
Galleria degli Uffizi, Florence

This chapter begins with an overview of Botticini's early artistic training within the tradition of workshop practice. Tracing the development of his artistic style, we will compare his works with those of his predecessors and contemporaries, such as Neri di Bicci, Fra Filippo Lippi, Sandro Botticelli, Andrea del Verrocchio and the brothers Antonio and Piero del Pollaiuolo, to demonstrate how his paintings came to be misidentified or overlooked by scholars over the centuries. The chapter will identify the main characteristics of Botticini's style and will examine his surviving drawings together with new technical evidence to consider what these reveal about his workshop practice. It concludes with a discussion of how key works, such as the *Assumption*, came to be re-associated with his hand.

Francesco Botticini (1446–1497)

Francesco Botticini must have received his earliest artistic training from his father Giovanni, a modest painter of playing cards. Indeed, many artists in this period were born into a family of artists, a structure that ensured a stylistic coherence and continuity, particularly for large projects where many artists were needed and often worked simultaneously as a team. Training traditionally began at an early age, sometimes as early as seven or eight, but assistants usually began their formal apprenticeships in their early teens. In exchange for their help in the workshop, the master painter would train his assistants and provide them with a room, board and sometimes a modest salary.

At the age of 13, Botticini joined the successful workshop of Neri di Bicci (1418–1492) as a salaried assistant. This gave him access to a substantially higher level of expertise than working with his father. Neri had inherited his well-established workshop in the 1440s from his father, who had in turn inherited it from his father. The workshop was so large that it encompassed two sites, and was especially known for its production of altarpieces and smaller devotional pictures intended for the domestic interior that were often replicated by the workshop numerous times. Neri's artistic style, particularly around 1459/60 when Botticini was assisting him, was highly decorative and technically accomplished, but his figures were largely expressionless and doll-like and he tended to adopt and re-use figures and architectural motifs from more accomplished artists like Fra Filippo Lippi (about 1406–1469) and Domenico Veneziano (active 1438; died 1461). It is clear from a predella panel painted by Botticini while in Neri's workshop

that his earliest works share the colour palette as well as the figural and
architectural types of Neri's preferred artists.[2] The predella, subsequently
dismembered and dispersed to collections around the world, is painted
with scenes from the *Life of the Virgin*, and represents the earliest surviving
work by the artist. Botticini left Neri's workshop after only nine months to
establish himself as an independent artist. By 1469 he had certainly set up
his own workshop, as a document of that date describes him as a *dipintore*
(painter).[3] In 1471, he joined the Confraternity of the Archangel Raphael and
painted an altarpiece for their chapel in the church of Santo Spirito, probably
the beautiful *Three Archangels with Tobias*, 1471–2 (fig. 44).

The *Three Archangels* is an accomplished work, as seen, for example, in the
delicate rendering of the river valley landscape, which recedes convincingly
into the distance and in the execution of the magnificent armour worn
by the Archangel Michael with its highly reflective finish. In these details,
Botticini reveals his close observation of the dynamic figures and evocative
landscapes of the Pollaiuolo brothers, visible, for instance, in Piero del
Pollaiuolo's *Apollo and Daphne,* dated between 1470 and 1480, and Piero and
Antonio's collaboration on the large *Saint Sebastian* altarpiece completed
about 1475 (figs 45 and 46). These brothers were born some 10 years apart
and while Antonio, the older brother, first trained as a goldsmith and as
a sculptor in the Florentine workshop of Lorenzo Ghiberti (1378–1455),
his brother Piero trained as a painter, perhaps with Andrea del Castagno
(around 1421–1457). While they became famous for their work in a variety

47
Possibly by FRANCESCO BOTTICINI
The Crucifixion, about 1471
Tempera on wood, 28.5 × 35 cm
The National Gallery, London

of media such as bronze sculpture, embroidery and engraving, and for their representation of the male body in action, it is their remarkable rendering of the glimmering Arno river valley (see also detail, fig. 34), using subtle tonal changes to suggest the receding landscape, that seems to have impressed Botticini the most. Indeed, in *The Crucifixion,* a panel formerly attributed to Andrea del Castagno and now given to Botticini, and dated around 1471, the artist includes a similar valley landscape (which has darkened somewhat over time), with a winding path or river receding towards a dramatic mountain range in the far distance (fig. 47). This clever narrative and compositional motif draws the viewer into the picture and encourages a kind of visual pilgrimage through the landscape; a device that Botticini would develop and re-use throughout his career, culminating in his dramatic panorama in the Palmieri altarpiece.

If the landscape in the *Three Archangels* seems lifted right out of a work by the Pollaiuolo brothers, so too does the figure of the Archangel

48

SANDRO BOTTICELLI
Saint Francis of Assisi with Angels,
about 1475–80
Tempera and oil on wood, 49.5 × 31.8 cm
The National Gallery, London

Michael at the far left.[4] By contrast, the other two Archangels look far more like Botticelli's angels of the same period (fig. 48). Botticelli was an exact contemporary of Botticini in Florence and, at the height of his fame, was one of the most esteemed artists in Italy. Unlike Botticini he did not grow up in an artistic family and so was sent to work as an apprentice, probably to Maso Finiguerra, a goldsmith, before entering the studio of the artist Fra Filippo Lippi, who worked for many of the leading families in Florence, including the Medici. Botticelli's early style was deeply indebted to the lyrical and decorative style of his master, Fra Filippo and, when he established his own workshop in 1470, he even employed his late teacher's son, Filippino Lippi, as his apprentice. Their styles became especially close, characterised by a bright colour palette, strong contour lines and a kind

of sweet, ornamental charm. In some cases their styles became almost indistinguishable, particularly when one completed the work begun by the other. An interesting case of such a collaboration is found in the National Gallery's *Adoration of the Kings* (fig. 49), which was begun by Filippino, the younger pupil, and completed by Botticelli, the master, a reversal of the practice we would normally expect.

By contrast, there is a distinct difference in the style and treatment of the different figures in Botticini's *Three Archangels*, suggesting he may have assigned parts of the painting to members of his workshop. This was common practice in Florence in the fourteenth and fifteenth centuries. At the centre of the panel, the Archangel Raphael is shown in an elegant, relaxed pose with his draperies billowing out behind him in soft folds. The figure of the Archangel Gabriel, at the far right, appears relatively stiff by contrast, holding his lily in a difficult, overly mannered pose and with his head tilted at an angle that does not sit comfortably with the orientation of the rest of his body. The awkward angle at which he holds the lily, combined with his exceptionally elegant right hand, suggests the use of a cartoon for the hand, that is, a detailed preparatory drawing on paper made by the master that could be used or copied by studio assistants for different paintings, a customary workshop practice. All the hands of the figures in this work are particularly expressive, and the distinctive way the artist has painted both Michael and Gabriel with their little fingers spread exaggerately from the rest of the hand (quite a difficult pose to hold in reality) recalls figures in

49
SANDRO BOTTICELLI and FILIPPINO LIPPI
Adoration of the Kings, about 1470
Tempera on wood, 50.2 × 135.9 cm
The National Gallery, London

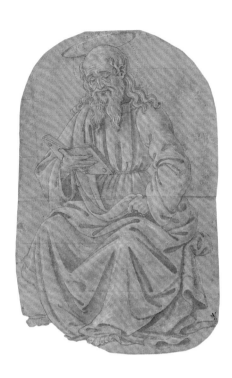

50

FRANCESCO BOTTICINI?
(attributed to Alesso Baldovinetti
by some scholars)
A Seated Saint reading from a Book,
late fifteenth century
Brush and brown ink, brown wash,
heightened with white, pricked for
transfer, 26.1 × 16.2 cm
The Metropolitan Museum of Art,
New York (Robert Lehman Collection,
1975.1.409)

works by the Pollaiuolo brothers and by Verrocchio and his workshop.[5]
The combination of styles and figural types suggests that the artist was
looking at a variety of visual sources that he was unable to combine
entirely harmoniously, an effect perhaps compounded by the work of
assistants. It is hardly surprising therefore that the attribution of this
painting has led to a great deal of debate by scholars over the centuries.
The *Three Archangels* was attributed to Botticelli in the sixteenth century,
an attribution only questioned in the mid-nineteenth century when the
art historians Sir Joseph Archer Crowe and Giovanni Battista Cavalcaselle
called it 'style of the Pollaiuolo brothers' instead.[6] A second group of art
historians writing in the late nineteenth century, including Wilhelm von
Bode, Bernard Berenson and August Schmarsow, suggested that the painting
was by Verrocchio instead, while others still maintained the attribution
to Botticelli.[7] Since the twentieth century, however, scholars have largely
considered the work as by Botticini, although the suggestion that he had
access to preparatory drawings by Verrocchio or Botticelli might account
for the disparity in the treatment of each figure.[8] The painting is currently
undergoing conservation treatment and technical study, the results of which
may provide new insight into Botticini's early artistic process.

In addition to altarpieces, Botticini painted a few portraits, a great
number of works for private devotion and, most probably, designs for
embroideries (fig. 50). His smaller devotional works are predominantly of
the Virgin and Child (figs 51 and 52), and his workshop became especially
known for the production of decorative, domestic paintings. In these works,
mostly dating to the mid- to late 1470s, his figural types, particularly that
of the Virgin Mary, are especially close to those of Andrea del Verrocchio
(around 1435–1488), one of the leading Florentine artists of the period.
Although primarily celebrated for his sculpture, Verrocchio was also a
successful painter who trained a number of important artists in his studio,
including Botticelli, Perugino, Domenico Ghirlandaio, Lorenzo di Credi,
Biagio d'Antonio and, most famously, Leonardo da Vinci. Verrocchio
appears to have employed assistants for most of his paintings, not all of
whom have been identified. Botticelli is thought to have been active in
Verrocchio's workshop for a time in the late 1460s and the similarity of
Botticini's works to those of Verrocchio has led some scholars to speculate
that he too was employed in the master's studio. In Florence, Verrocchio
worked extensively for the Medici family, serving therefore as the nucleus of
a powerful network of artists and patrons.

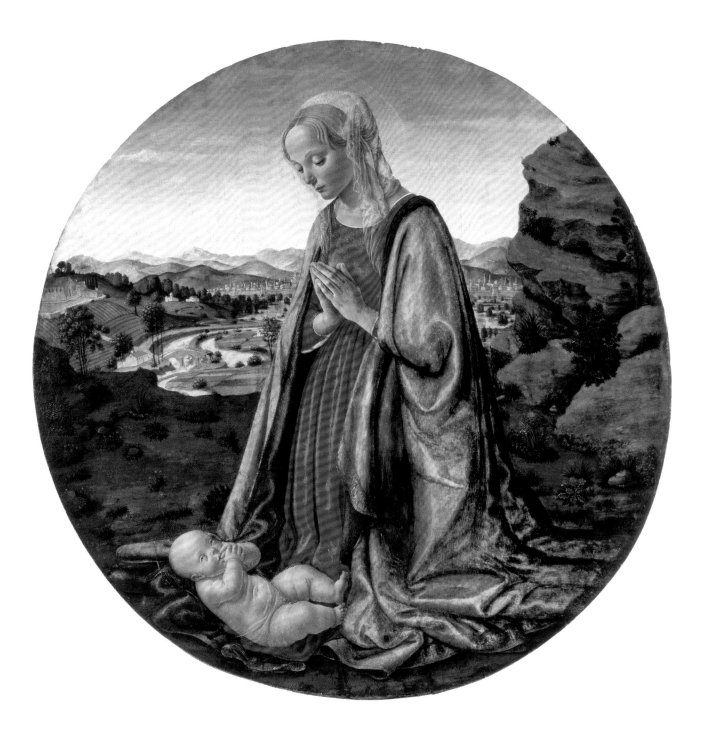

51

FRANCESCO BOTTICINI
The Virgin adoring the Christ Child,
about 1475–80
Tempera on wood, diameter 106.5 cm
Collezione Credito Bergamasco –
Gruppo Banco Popolare, Bergamo

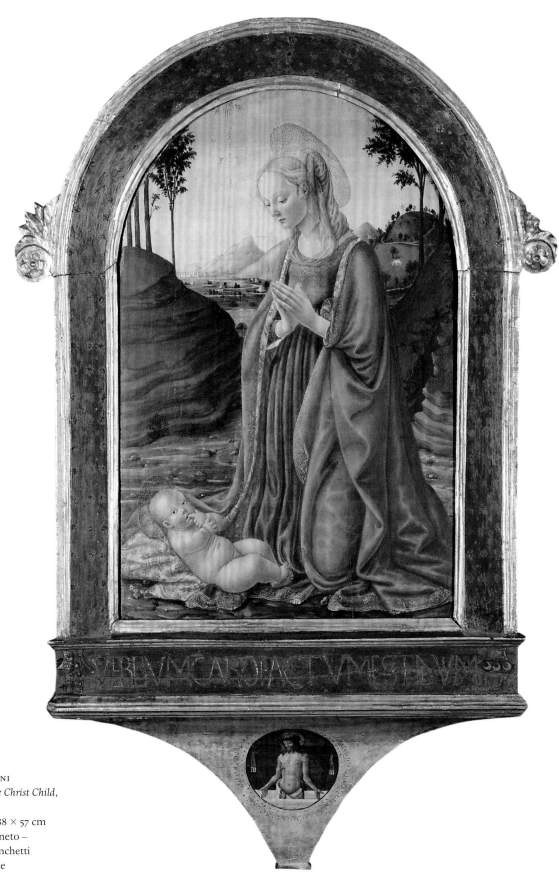

52
FRANCESCO BOTTICINI
The Virgin adoring the Christ Child,
about 1475–80
Tempera on wood, 88 × 57 cm
Polo Museale del Veneto –
Galleria Giorgio Franchetti
alla Ca' d'Oro, Venice

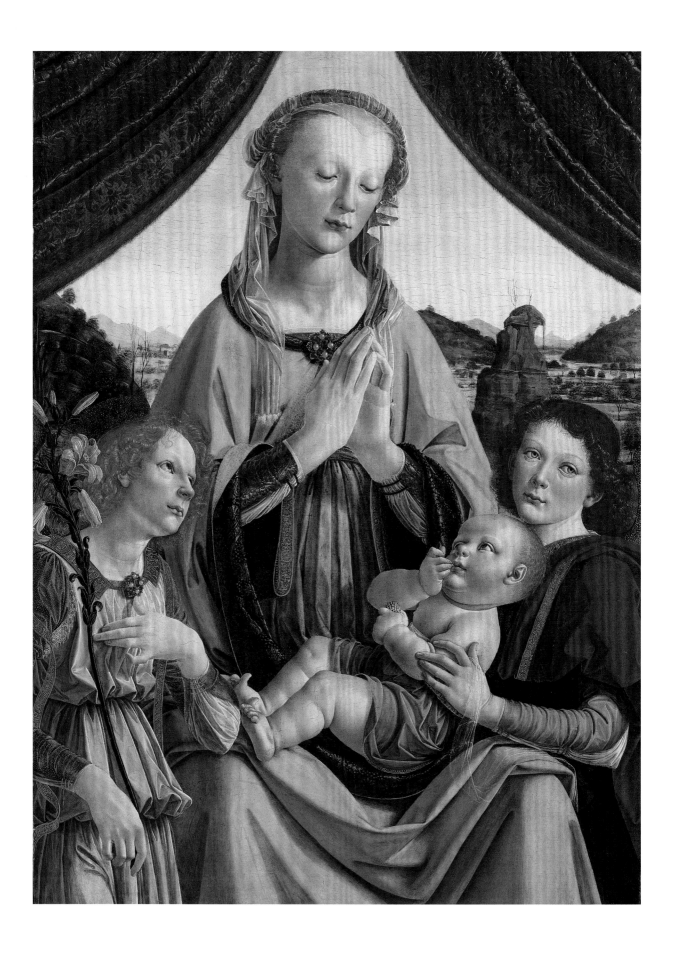

Botticini's artistic response to Verrocchio is varied. In some cases he borrows entire figures from works by Verrocchio and his workshop, while in others he adopts only the complicated arrangement of draperies that fall in deep sharp folds as visible in the drapery studies and paintings they made in the 1470s (fig. 54).[9] Above all, Botticini adopted Verrocchio's model of the Virgin Mary. In both his tondo (fig. 51) and his arch-topped panel (fig. 52) of *The Virgin adoring the Christ Child* for example, Botticini represents the Virgin as a beautiful young Verrocchiesque blonde, with head slightly bowed and demurely lowered eyes. She has the same broad, smooth forehead, delicate features and gauzy transparent veil of Verrocchio's Madonnas (fig. 53).

Botticini returned to the subject of the Archangels some years after his Confraternity altarpiece, to paint a smaller panel for the domestic interior of the Archangel Raphael and Tobias, around 1480, now in the Accademia Carrara, Bergamo (fig. 55). The work was acquired by the Accademia as a Botticelli in 1871. It was subsequently attributed to the workshop of Verrocchio by Bode, among others, in 1882, who must have noted its similarity in composition and treatment to works such as *Tobias and the Angel* by the workshop of Verrocchio and dated between 1470–5 (fig. 56). The Accademia painting was

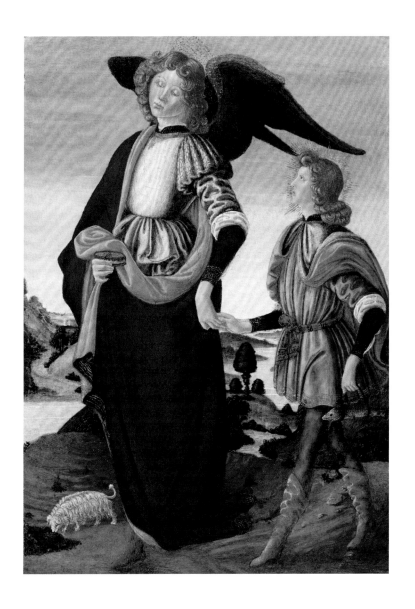

FRANCESCO BOTTICINI
Archangel Raphael and Tobias, about 1480
Tempera on wood, 54 × 40 cm
Accademia Carrara, Bergamo

only reattributed to Botticini by Berenson in 1900. Although the panel clearly owes a great deal to Verrocchio, Botticini has here simplified the treatment of the clothing and landscape, both of which are distinctly unlike those of the Pollaiuolo brothers but much closer to the sweet, lyrical and more decorative style of Botticelli.

Broadly speaking, Botticini's artistic style seems to have developed from an early manner whose figures and compositions looked directly to his master, Neri di Bicci, but also incorporated the sweet lyricism of Fra Filippo Lippi combined with the kind of architectural settings favoured by Domenico Veneziano. From the early 1470s, Botticini's works appear more distinctly Verrocchiesque, all the while borrowing elements, such as the dramatic receding landscapes of the Arno valley, from contemporary paintings by the Pollaiuolo brothers. From about 1475 onwards he appears to be more influenced by Botticelli. His figures become elongated and there is an increased attention to outline, pattern and use of bright, primary colours.

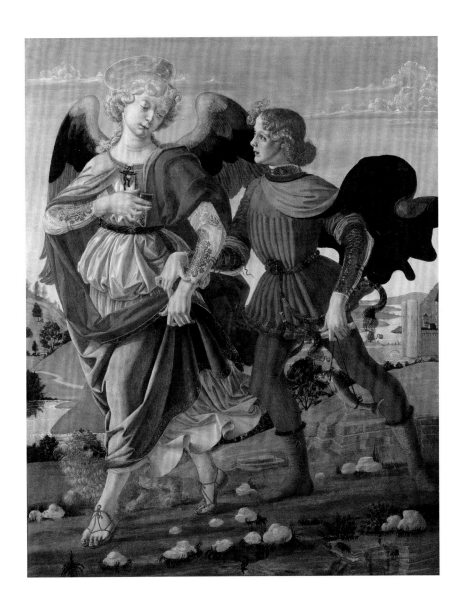

56
Workshop of ANDREA DEL VERROCCHIO
Tobias and the Angel, about 1470–5
Tempera on wood, 83.6 × 66 cm
The National Gallery, London

His altarpiece of the *Assumption* falls precisely into this period, where the dress and physiognomies of the angels recall Botticelli but the attention to the drapery folds and the way they are represented falling in stiff, deep folds recall the drapery studies of Verrocchio and his workshop.

The fall of a figure's draperies and how they reflect or absorb the light are preoccupations reflected in two of Botticini's surviving preparatory drawings made for the Palmieri altarpiece (both in the Nationalmuseum, Stockholm). These drawings, executed in pen and ink, belong to a relatively late stage in the planning of the altarpiece and provide insight into Botticini's working methods. The first sheet, showing a study for the blessing Christ is a highly worked-up study that closely corresponds to the figure in the finished work (fig. 57). While all of the elements of the final figure are neatly indicated in swift, confident strokes of the pen, the focus of this study is primarily on the dramatic V-shaped folds of the fabric between the figure's knees and, as indicated by the strong hatching, the way the shadows

 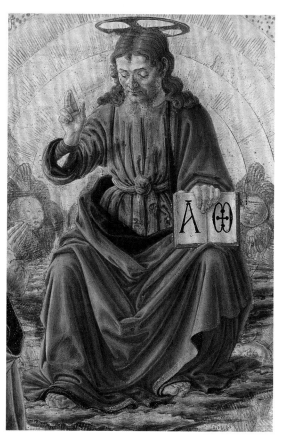

Ghirlandaio

fall across these undulating surfaces. In the second sheet, *Christ blessing the Kneeling Virgin. Two Angels*, Christ is shown again, at the lower left, in a gesture of blessing that roughly corresponds to his pose in the painting (fig. 59). At his feet, the Virgin kneels to receive her blessing. Here the artist appears to be working out the spatial relationships between the two figures and their responses to each other. To the right of these diminutive figures are two angels seated in different poses, their larger scale suggesting that they were the primary focus of this sheet and that smaller figures at the lower left represent a later, swift jotting down of ideas for another part of the composition. The angel on the far right corresponds to the figure carrying a bundle of fasces (rods traditionally carried by a lictor in ancient Rome as a symbol of a magistrate's power) in his right hand and seated to the right of Saint Andrew (carrying a cross) in the sixth row of the angelic hierarchy in the altarpiece (fig. 60). The angel at the centre of the sheet, however, was not used in the final painting.

(opposite, top left)
57
FRANCESCO BOTTICINI
Christ giving his Blessing, about 1475
Pen and brown ink, 18.5 × 11 cm
Nationalmuseum, Stockholm

(opposite, top right)
58
FRANCESCO BOTTICINI
Detail from *The Assumption of the Virgin*.

(opposite, bottom)
59
FRANCESCO BOTTICINI
Christ blessing the Kneeling Virgin.
Two Angels, about 1475
Pen and brown ink, 11.2 × 16.3 cm
Nationalmuseum, Stockholm

(right)
60
FRANCESCO BOTTICINI
Detail from *The Assumption of the Virgin*.

FRANCESCO BOTTICINI
Detail from *The Assumption of the Virgin*,
showing an angel (centre) painted in a
distinctly different manner from those
surrounding him.

New infrared reflectography of Botticini's *Assumption* has revealed a
great deal of the preparatory underdrawing made on the panel before the
colours were added. Some of this underdrawing, executed in black paint
on the prepared panel, is now even visible to the naked eye, particularly in
places where the paint layers on top have faded, such as in the red pigments
used for the robes of the angels in the lowest rank of Heaven. The extensive
underdrawing of the angels draperies recalls that in the surviving drawings
and indicates that very little was left to chance. It may also suggest that
Botticini himself ensured that each figure was carefully underdrawn before
assigning the painting of a particular area to one or several workshop
assistants. Indeed, there appears to have been at least three hands at work
on this large panel, if not more, as revealed for example by comparing an
angel at the far right, whose hair appears distinctly more pattern-like when
compared to the soft flowing waves of the angelic figures surrounding him
(fig. 61). Similarly, the figures of the apostles below, which are especially
close to Botticelli and Filippino, seem to have been painted by a different,
slightly less accomplished, hand than the rest of the heavenly host. Given
that we know that Botticini had already established a workshop some
years before receiving this commission, it would be more surprising if
he had not employed workshop assistants for such a large and labour-
intensive undertaking.

Botticini's mature style, seen in the works he produced after the
Assumption (completed by 1477), seems to develop along the same lines as
Botticelli's, although he translates the artist's compositions and motifs into
somewhat more literal, less fanciful terms. A case in point is the *Tabernacle
of Saint Sebastian* (fig. 63), made for a chapel in the church of the Collegiata
in Empoli between 1477–80.[10] In this elegant work, also mistakenly praised
by Vasari as by Botticelli, Botticini painted two large angels with swirling
draperies against a dramatic black background. They stand on tiptoe, as
if just alighting at the sides of the marble sculpture of Saint Sebastian by
Antonio Rossellino located in a niche at the centre of the altarpiece. These
Botticelli-like angels present the donors, members of the Capacci family,
kneeling at their feet. In the predella below, Botticini has freely painted
detailed, whimsical and anecdotal scenes from the life of Saint Sebastian.
This exceptional work stands in contrast to the treatment in some of his
later works, such as his *Madonna and Child Enthroned with Saints and Angels*,
painted around 1495 (Metropolitan Museum of Art, New York), in which
the figures appear more rigid and mechanical compared to his earlier,

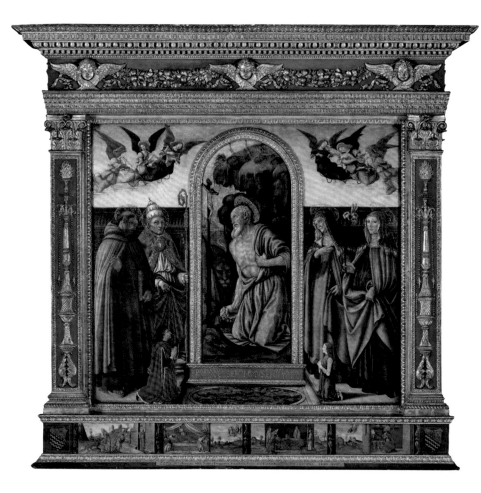

62
FRANCESCO BOTTICINI
*Saint Jerome in Penitence, with Saints
and Donors*, about 1490
Tempera on wood, 235 × 258 cm
The National Gallery, London

63
FRANCESCO BOTTICINI
and ANTONIO ROSSELLINO
The Tabernacle of Saint Sebastian,
about 1476
Panel and marble
Museo della Collegiata
di Sant'Andrea, Empoli

more fluid works. In this altarpiece for example, the saints are positioned in a formal, funnel-like, arrangement at the foot of the throne of the Virgin, their hair and beards rendered in stiff unmoving waves and their draperies similarly arranged in rigid folds.

Interestingly, several of Botticini's late works were formerly attributed to Cosimo Rosselli (1439–1507), a Florentine painter who had also trained with Neri di Bicci and later collaborated with Botticelli among other artists on the frescoes of the walls of the Sistine Chapel.[11] For example, the altarpiece of *Saint Jerome in Penitence, with Saints and Donors* (fig. 62), painted around 1490 for the Rucellai family for San Girolamo, Fiesole, was acquired by the National Gallery as a work by Rosselli in 1855.[12] Now generally accepted as by Botticini, this unusual and innovative altarpiece is composed as a picture within a picture. The painting represents four saints and two kneeling donors venerating Saint Jerome, who is represented as an independently framed figure in the centre of the panel. The narrative panels of the predella are painted in a slightly different style, and may be the work of Francesco's son, Raffaello (1474–1520), who also collaborated with his father on another work, the monumental *Tabernacle of the Sacrament* (Museo della Collegiata di Sant' Andrea, Empoli), an altarpiece begun by Botticini in 1484 but left unfinished at his death and only completed by his son in 1504.

As Francesco Botticini clearly enjoyed considerable popularity in his own day, it is surprising that his identity had already been forgotten by the time Vasari was writing the first edition of his *Lives of the Artists* in 1550, only a few decades after the death of Francesco's son, Raffaello. Given that so little was known about Botticini in the mid-nineteenth and early twentieth centuries, a period marked by a great flowering of interest in Italian Renaissance art, scholars and connoisseurs were left to conjecture about the origins and identities of many lesser-known artists based on what they did know, or what they believed, about better-known or better-documented artists. It is interesting to note that although Botticini's identity remained obscured until the late nineteenth century, the praise for his works, regardless of their authorship, was clearly sustained over the centuries.

Botticini's resurrection

The name 'Botticini' was literally unknown to modern scholars until the end of the nineteenth century when the Italian art historian Gaetano Milanesi (1813–1895) found a document dating to 1499 that referred to an artist known as Raffaello, the son of Francesco who was the son of Giovanni Botticini.[13] Curiously, no other surviving documents include the name 'Botticini', and references are simply made instead to Francesco di Giovanni (that is, Francesco, son of Giovanni). However, since Milanesi's discovery, art historians have referred to the Botticini dynasty and the family of artists has been known by that name ever since.

In a series of studies published between 1882–8, the distinguished German art historian Wilhelm von Bode (1845–1929) grouped together a number of works based on their stylistic affinities to works by Verrocchio but which he felt were of slightly inferior quality. He believed that these works were all executed by the same unknown artist who he named the 'Master of the Rossi altarpiece' based on an inscription in one of the works, a *Crucifixion with Saints* (destroyed, Berlin), indicating that it was commissioned by a member of the Rossi family in 1475.[14] Among the works identified by Bode were the *Assumption* altarpiece for Palmieri and the *Saint Jerome in Penitence* (see figs 2 and 62). It was another German art historian, August Schmarsow (1853–1936), who connected the Berlin *Crucifixion* with the painter of the *Tabernacle of the Sacrament* at Empoli, which, at that point, was the only documented work by an artist called Francesco di Giovanni.[15] In his book on Florentine Renaissance artists, Schmarsow both added a

few works to Bode's initial group of paintings and rejected a few.[16] Building on this research, the renowned American art historian Bernard Berenson (1865–1959) consolidated and published a large corpus of works he believed to be by Botticini in his *Florentine Painters* in which he correctly identified the artist as a pupil of Neri di Bicci, who was influenced by Castagno, Rosselli, Verrocchio and Botticelli.[17]

It was the Englishman, Herbert Horne (1864–1916), an architect, designer and art historian, who first identified Botticini as the artist responsible for the exquisite illuminations of Palmieri's *Città di Vita* (see figs 26–31). Horne had published extensively on the work of Botticelli, an interest that presumably encouraged his study of Botticini. Although he never published a study on the lesser-known artist as appears to have been his intention, Horne shared his manuscript discovery with Berenson who did.[18] Furthermore, in his 1938 edition of *The Drawings of the Florentine Artists*, Berenson also identified the two surviving preparatory drawings by Botticini for the Palmieri altarpiece discussed above.

The complicated history of the painting since 1784 demonstrates the difficulties inherent in identifying paintings and painters once a work has been removed from the place for which it was created. The Palmieri altarpiece was acquired by the National Gallery as a work by Botticelli at the Hamilton sale, on 24 June 1882.[19] The painting had already passed through several hands by that date and its full provenance is not entirely clear. It was certainly installed in the church of San Pier Maggiore by 1477 where it remained (it is recorded there by visitors to the church) until the church's destruction in 1784, at which time it is said to have passed to Palmieri's descendants. Conflicting accounts indicate that it was then installed in the Palmieri house in Florence or in the Villa in Fiesole.[20] Neither of these accounts are convincing, however, as by this date, the Villa had been sold to the 3rd Earl Cowper (1738–1789) and Palmiero Palmieri had sold the house on the Via Pietrapiana (formerly Via degli Scarpentieri) in 1710.[21] The altarpiece was seized by the French, presumably during the Italian campaigns of the French Revolutionary Wars (1792–1802), and deposited in the Accademia di Belle Arti in Florence until it was reclaimed by the Brocchi family, descendants of the Palmieri, at some point in the early nineteenth century.[22] The painting was apparently sold by a certain Signora Brocchi to Luigi Riccieri at an unknown date.[23] It was with the German art dealer Johann Metzger in Florence by 1828 and was bought by the London-based art dealer Samuel Woodburn in January 1844 from an unspecified picture dealer in Florence.[24]

Woodburn imported the work, along with over seventy more Italian pictures, to England, where he intended to sell them to the National Gallery.[25] The pictures were offered 'en bloc' to the Gallery in 1847 but the Trustees deferred making a decision. The Trustees asked Woodburn if he would consider selling them a portion of the collection instead, first offering to buy seven pictures and then reducing this number to two. Woodburn, frustrated by this series of negotiations, finally declined their offer. In 1849, he offered the 'Botticelli' to Alexander Douglas, 10th Duke of Hamilton. Surviving receipts indicate that the work was sent to Hamilton Palace on 13 December, 1849 and that the Duke paid £1000 for the panel.[26] Although Hamilton Palace was demolished in 1927, an inventory of 1853 describes the *Assumption* in the 'tribune'. It was described as hanging in the 'hall' (perhaps the same place) the following year by the German art historian, Gustav Waagen.[27] The painting was lent by the 12th Duke of Hamilton to an exhibition of Old Master paintings at the Royal Academy in 1873 (no. 191) and was acquired by the National Gallery at the Hamilton sale in 1882 for £4,777 10s.[28]

Palmieri's patrimony

Palmieri's long-standing association with the church of San Pier Maggiore and his collaboration with Botticini on the manuscript of the *Città di Vita* made them preferred candidates for the location and decoration, respectively, of his funerary chapel. Surviving documents reveal that Botticini began work on Palmieri's altarpiece in the first months of 1475 and completed it in 1477.[29] While the initial contract for the painting between Botticini and Palmieri does not survive, it is referred to in later documents and, following Palmieri's death in April 1475, a second contract was drawn up between Botticini and Palmieri's widow Niccolosa.[30] It was presumably at this point that Niccolosa asked Botticini to portray her in 'widow's weeds', the black garb of a mourning widow.[31] As the Palmieri family did not own the rights to a chapel in San Pier Maggiore at the time of Matteo's death, the original intended location of his altarpiece remains unknown. However, as Palmieri clearly stated his desire to be buried in the church in his will of 1469 and, given that his mother, father and uncle were buried there, it is likely that he intended Botticini's altarpiece to adorn that church.

As several seventeenth-century accounts of San Pier Maggiore indicate, Palmieri's father and uncle were buried, presumably in a floor vault, below the nuns' choir.[32] The nuns' choir was a loft or balcony-type space elevated

on two arches and supported by columns in the right (south) aisle of the church, which gave the nuns private access to the ceremonies and rituals celebrated below (see fig. 17).[33] It is possible that the altarpiece was originally made to adorn the unusually proportioned wall-space located below the choir loft and this may in part explain the panel's striking horizontal format. Botticini cleverly exploited this form by filling the lower register with a broad panoramic landscape and the upper register with a perspectival dome reminiscent of the cupolas or lanterns often surmounting chapels, effectively creating a sense of a vast space extending beyond the limits of this makeshift 'chapel'. In this location, the tomb of the Virgin, painted at the centre of Botticini's composition, would have recalled that of the Palmieri family located on the floor in front of the altarpiece in the church. Similarly, the Virgin's reception into the celestial dome above would have merged, visually, with the loft overhead, transforming the nun's choir into a kind of extended realm of the Heavens.

The altarpiece, however, seems never to have occupied the space below the nuns' choir as was previously believed.[34] This is because Niccolosa and Palmieri's nephew, Antonio, managed to obtain permission to build a new chapel in the right transept of San Pier Maggiore in April of 1476.[35] Presumably the design of the chapel took the composition and dimensions of Botticini's painting into consideration and the altarpiece must have been installed on the chapel altar shortly after it is recorded as being handed over to the patrons in or around June 1477.[36] The Virgin's reception into Heaven, as represented in the altarpiece, was a model for Palmieri's own, hoped for, reception following his journey: down from the Elysian Fields to Earth, Hell and back up the Mount of Virtues to the Empyrean Heaven, as described in the *Città di Vita*.

Angelic Hierarchies

64

NARDO DI CIONE
Paradise, 1354–7
Fresco
Strozzi Chapel (south wall),
Santa Maria Novella, Florence

The mingling of angels, saints and Old Testament figures in Botticini's altarpiece has caused confusion and debate among scholars perhaps more familiar with neat angelic hierarchies as often arranged by artists in manuscript illuminations and scenes of the Last Judgment. Indeed, many artists have followed the model put forward by theologians such as the Pseudo-Dionysius in his *De Coelesti Hierarchia* (*On the Celestial Hierarchy*) in the fifth century and taken up again by Saint Thomas Aquinas in the *Summa Theologica* in the thirteenth century.[1] This broadly accepted model consisted of a nine-tier hierarchy of the heavenly host subdivided into three spheres.

Palmieri was clearly familiar with this model as he specifically refers to these ranks of the angelic orders in the *Città di Vita*, where he also indicates that only the superior orders are able to see God and are charged with communicating God's truths to the tiers below.[2]

Given the precision of Palmieri's angelology in the poem, it is perhaps surprising to see the intermingling of angels, saints, Old Testament figures and a sibyl in seven of the nine angelic tiers of Botticini's painting. This arrangement is unusual but not unprecedented and may have been inspired by Nardo di Cione's monumental *Paradise* fresco, painted in the 1350s, in the

Strozzi Chapel in the church of Santa Maria Novella, Florence. Nardo's fresco represents angels interspersed with the elect, all arranged in neat rows around and below the enthroned figures of Christ and the Virgin (fig. 64). This immense fresco fills the left-hand wall of the Strozzi chapel much like Botticini's enormous painting must have occupied the wall of the Palmieri chapel, in a manner more akin to mural decoration than altar adornment.

Each tier of the angelic host in Botticini's altarpiece is distinguished through physical appearance, colour of clothing or by attribute, as identified and discussed further below.

FIRST SPHERE

The first, uppermost sphere represents the heavenly counsellors: Seraphim, Cherubim, and Thrones (or Ophanim). The six-winged red Seraphim are clearly distinguished from the four-winged blue Cherubim below who, together, are the heavenly creatures who stand closest to the throne of God. The Thrones beneath them appear to have six blue wings and are shown bust-length (rather than the disembodied winged heads of the Seraphim and Cherubim) and appear without their traditional wheels, sometimes included to suggest their role as carriers of the throne of God.

SECOND SPHERE

The middle sphere is populated by the heavenly governors: Dominions (or Lordships), Virtues (or Strongholds) and Powers (or Authorities). The Dominions regulate the duties of the lower angels and are shown dressed in white and carrying fasces, a bundle of rods traditionally carried by a lictor in ancient Rome as a symbol of a magistrate's power. Beneath them, the Virtues, who supervise the movements of the heavenly bodies and ensure the order of the cosmos, wear blue and carry flaming torches. Below them are the Powers in green. They are the warrior angels, here shown carrying spears, created to be completely loyal to God and whose duty it is to oversee the distribution of power among humankind.

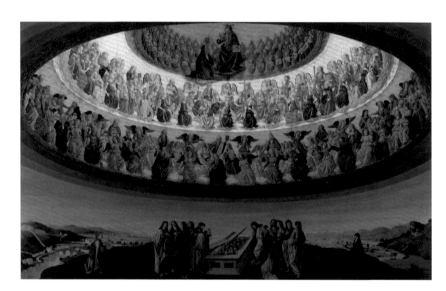

THIRD SPHERE

In the lowest sphere are the heavenly messengers and soldiers: Principalities (or Rulers), Archangels, and Angels. The Principalities, in blue, hold wands aloft, possibly alluding to their collaboration with the Powers above. They are the educators and guardians of the Earth. Below, Archangels in white carry unidentified vessels.[3] As the guardians of nations, they are concerned with politics, military matters and commerce. The Angels, in red below, direct their rods downwards, perhaps referring to their role as messengers to mankind.

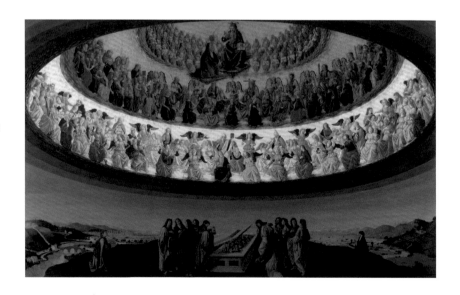

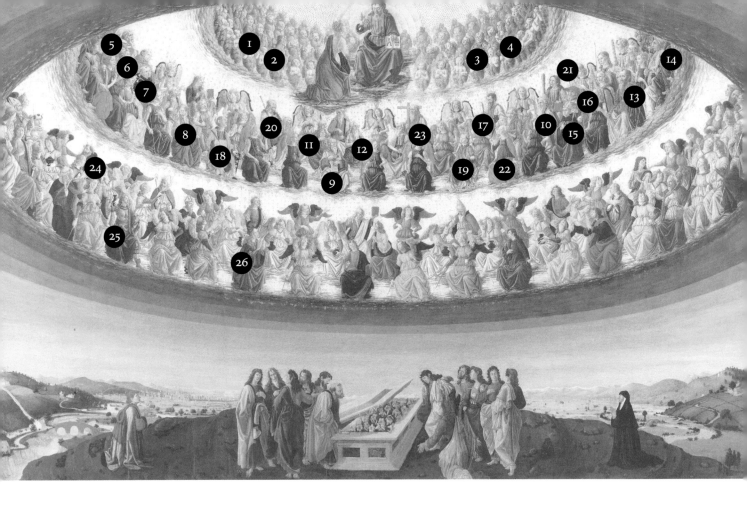

Identifying the Saints

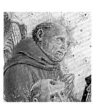

1. SAINT PETER

A white-bearded old man holding a set of keys to the gates of Heaven and Hell. Peter was the titular saint of San Pier Maggiore and was described by Palmieri in the *Città di Vita* in this, penultimate, realm of Heaven.[4]

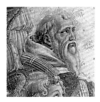

2. SAINT JOHN THE BAPTIST

The Baptist carries his traditional reed cross and wears animal skins. His prominent position befits his role as Christ's precursor and baptiser and as patron saint of Florence. Palmieri describes him in the highest realm of Heaven, just below the Virgin.[5]

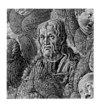

3. AN EVANGELIST (MATTHEW?)

This figure must be an Evangelist, as indicated by his quill-pen and book. He may be Matthew (Palmieri's name saint) or Mark (for Palmieri's father). Palmieri describes John, however, as *il più degno* (the most worthy) of the Four Evangelists.[6]

4. SAINT MARY MAGDALEN

Identified by her traditional red cloak and the pot of ointment with which she anointed Christ's body, the Magdalen is both the patron saint of apothecaries, of particular appeal to the Palmieri family, and the name saint of Palmieri's sister.

5. SAINT BENEDICT

A white-bearded man carrying a bundle of rods for corporal punishment is probably Benedict, a key figure for the Benedictine church of San Pier Maggiore. The saint wears white robes (more commonly worn by members of the reformed Benedictine Order) rather than the traditional black.[7]

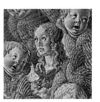

6. SAINT FRANCIS OF ASSISI

The founder of the Franciscan Order is recognisable from his traditional brown habit and tonsure (a haircut in which the crown of the head is shaved).

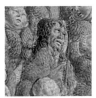

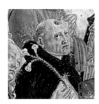

7. SAINT DOMINIC

Dominic, the founder of the Dominican order, is located immediately below Francis. He holds a book and a lily and wears the black and white robes of his order.

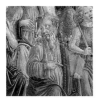

8, 9 & 10. MOSES, DAVID, ABRAHAM

These Old Testament prophets are distinguished by their long white beards and attributes. Moses (illustrated) holds the Tablets of the Law (8), David (9) holds a lyre (a reference to his role as musician and Psalmist) and Abraham (10) the knife he meant for the sacrifice of Isaac.

11 & 12. ADAM AND EVE

The first man and woman are shown as an elderly couple, with long flowing white hair and clothed in animal skins.

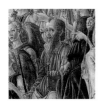

13. PAUL THE APOSTLE

Paul holds his traditional attribute of the sword with which he was executed and the book of his Epistles.

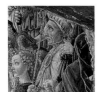

14. A POPE (PAUL II?)

A pope in full regalia, complete with papal tiara, crosier, gloves and episcopal rings, whose distinctive profile recalls that of the recently deceased Paul II (Pietro Barbo, 1417–1471).[8] The angel at his side points to his name saint, Paul, seated beside him.

15. SAINT AUGUSTINE

The Bishop of Hippo and a Doctor of the Church who promoted the notion of free will. He is identified by his bishop's mitre and crook, together with the black robes of his order visible under his blue mantle.

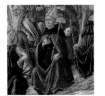

16. SAINT JEROME

The saint wears his red cardinal's garb and holds a book, probably an allusion to his translation of the Bible.

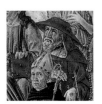

17. SAINT BARTHOLOMEW

A middle-aged dark-haired and bearded man holding a knife, a reminder of his martyrdom by being flayed alive. Bartholomew was the name saint of Palmieri's brother, who died young and whose children Palmieri raised as his own.

18. SAINT LAWRENCE

Lawrence, a young deacon saint wearing a dalmatic (a kind of liturgical vestment), holds a martyr's palm and the gridiron upon which he was tortured.

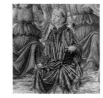

19. SAINT STEPHEN

Stephen mirrors Lawrence, the other young deacon saint seated opposite. He similarly wears a dalmatic and holds a martyr's palm. He was stoned to death.

20 & 21. SAINT JAMES THE GREATER AND SAINT JAMES THE LESS

The bearded apostle (illustrated) rests his pilgrim's staff on his shoulder while he prays. In the corresponding position opposite is James the Less holding aloft a fuller's club (a tool used by wool workers to compact material by beating it) with which he was killed.

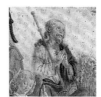

22. SAINT CATHERINE OF ALEXANDRIA

This virgin saint holds a martyr's palm aloft in one hand and rests her other on the spiked wheel upon which the Roman Emperor Maxentius sought to torture her.

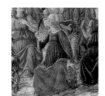

23. SAINT ANDREW

This white-bearded apostle was the brother of Saint Peter. He holds the wooden cross to which he was bound and crucified.

24. SAINT ANTHONY ABBOT

The founder of monasticism, he wears a dark brown habit, grey beard and tonsure.

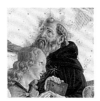

25. SAINT GEORGE

This beautiful young soldier saint stands out for his elaborate armour and the spear he carries in his right hand. He is appropriately positioned among the angels concerned with earthly and military endeavours.

26. THE CUMAEAN SIBYL

The only Heavenly figure without a halo of golden rays, she is also distinguished by her unusual sibylline headgear (see fig. 24). She must be the Sibyl believed to have foretold Christ's Passion and Resurrection and who served as Palmieri's guide through the afterlife.

Notes

Chapter 1

1. Shaw and Welch 2011, p. 24.
2. The apothecary shop is described as the *bottegha d'arte di spezieria in su Canto alle Rondini* in Palmieri's Catasto of 1430. See Cat. 386, fol. 259r. Cited in Taylor 1986, p. 24.
3. The current pharmacy (on the corner of Via Pietrapiana and Via dei Martiri del Popolo) occupies a site just east of the original location of Palmieri's shop that was demolished in 1936 to make way for the new Palazzo delle Poste (located at the corner of Via Giuseppe Verdi and Via Pietrapiana). On the apothecary shop see Bonsignori and Ragionieri 1969; Rocchietta 1986, p. 123.
4. Richa says that the house was decorated with the Palmieri coat of arms. See Richa 1754–62, vol. I, p. 153. Richa makes no mention, however, of the bust of Palmieri by Rossellino (now in the Museo Nazionale del Bargello, Florence). On the bust see Paolozzi Strozzi 2008.
5. We know the location of the men's tombs thanks to Gamurrini and Richa. Their names were apparently inscribed in the tombs in Lombard characters: '*Francisco, et Marco Palmeriis Antonii filiis Palmerio Equite originem ducentibus, atque Posteris, et suis amnibus…*'; see Gamurrini 1668–85, vol. III; 1673, p. 109; and Richa 1754–62, vol. I, p. 147. Richa devotes a whole section (XI) to San Pier Maggiore and returns to the subject in section VI, pp. 224–5. Messeri refers to Tommasa Palmieri's death but mistakenly says she was buried in the family chapel in San Pier Maggiore, see Messeri 1894, p. 47; Bagemihl 1996, p. 308 indicates that she was buried outside the church but not where he obtained this information. Mita Ferraro indicates that Tommasa died on 21 August 1462 but that Palmieri only declared her death in his tax return of 1468, Mita Ferraro 2005, pp. 33–4, n. 54.
6. Matteo Palmieri's *Libro dei Ricordi* or book of records are officially called the *Libro di Ricordi di Portate et altre Memorie diverse di messere Matteo di Marco di Antonio Palmieri*, and these, written in Matteo's own hand, contain various payments and tax declarations. The book is now in the Archivio di Stato di Firenze; c. 26v in the Portata al Catasto of 1433 reads: '*E anchora ogni anno a di 21 settembre* [the anniversary of his father's death] *fo un uficio in San Piero magiore, di 20 preti e lire 20 di cera, per l'anima di Marco, mio padre*'. The book is transcribed in Palmieri [1983], p. 65.
7. The patronal rights and dedications of the chapels in San Pier Maggiore are recorded in Stefano Rosselli, *Sepoltuario fiorentino ovvero descrizione delle chiese, cappelle e sepolture, loro armi et iscrizioni che sono nella città di Firenze e suoi contorni* (1657), p. 126. The manuscript survives in several copies including one in the Biblioteca Nazionale Centrale di Firenze, consulted here. I am grateful to Joanne Allen for drawing it to my attention.
8. Vespasiano da Bisticci [1970–7], pp. 563–7.
9. Cited in Taylor 1986, p. 12.
10. Cited in Mita Ferraro 2005, p. 37.
11. Goldthwaite 1980, pp. 348–50.
12. Cited in Goldthwaite 1980, pp. 349–50, n. 84.
13. Goldthwaite 1980, pp. 348–50.
14. While this must be in part due to the fluctuations in price and the increased value of the merchandise being sold it is nonetheless impressive. See Mita Ferraro 2005, p. 37.
15. See Mita Ferraro 2005, pp. 71–2.
16. On the Serragli see Martines 1963, p. 229ff.
17. In listing his dependents in his *catasti*, Matteo makes no mention of his brother's widow living with the Palmieri family. See Mita Ferraro 2005, pp. 33–4, n. 54.
18. In this declaration of 1457 Palmieri indicates that he is now 51 years old, and even though he and his wife don't have children of their own they have many mouths to feed and that their bills are very high. Palmieri [1983], p. 177.
19. He bought the villa from Nuccio di Benintendi Solosmei. Although the property is identified as Villa Schifanoia in Palmieri's tax declaration of 1469, it has long been known as Villa Palmieri (as it is still known today).
20. Boccaccio [1952], p. 21.
21. On the dating of the *Della Vita Civile* see Mita Ferraro 2005, pp. 181ff.
22. Palmieri [1982], Book I, 115, p. 37.
23. Palmieri [1717], pp. 525–7.
24. The Council focused especially on the contested nature of purgatory and on the phrase *Filioque* ('and from the Son') in the Nicene Creed, which maintains that the Holy Spirit proceeds from both the Father and the Son, a doctrine disputed by the Greeks who held that the Spirit proceeds from the Father only.
25. By extension this exploration resembles Cicero's own model: Plato's *Republic*. Palmieri no doubt also had in mind the *Politics and Ethics* of Aristotle, Quintilian's *Institutio Oratoria*, Plutarch's *Lives*, Virgil's *Aeneid* and many others. For a longer discussion on Palmieri's use of these sources see Carpetto 1984, chapter 3.
26. Palmieri [1982], p. 154.
27. Dante's *Divine Comedy* will be discussed in greater depth, alongside Palmieri's conception of the universe, in Chapter 2.
28. Dante's dead friend is said to appear to him while Dante is fighting the Ghibellines of Arezzo in 1289.
29. See Dati's commentary on the *Città di Vita*. The use of visions as a kind of formula derives from ancient texts and became popular among fifteenth-century authors in Florence. See for example Giovanni Morelli's *Ricordi* and Giovanni Cavalcanti's *Istorie Fiorentine*.
30. A more in-depth discussion of all of these offices is provided in Rubinstein 1966.
31. On the *Consulta e Pratica* see Taylor 1986, p. 32ff.
32. '*Vedutosi nella città quanto valeva ne' sua consigli, avendo a mandare ambasciadori al re Alfonso, mandorno Matheo. Fu assai onorato per la sua fama et delle lettere et dell'essere istimato uomo savio. Et a Napoli in questo tempo erano molti uomini literati, che avevano buona notitia di Matheo, per avere veduto l'opera sua*', Vespasiano da Bisticci [1970–7], p. 564.
33. See note above.
34. According to Gelli, Alfonso exclaimed '*pensa quel che sono a Firenze i Medici, se gli speziali vi son cosifatti!*' See Gelli 1978, p. 928.

35. 'Ad Napoli orator mi trovava io / Al re che Puglia a la sycilia regge / E celebrollo degno & sagro & pio. / Ire ad pozuol quella sera elegge / & I conlu seguitol quella via / dixi conviene oma chi cuma vegge. / Cuma famosa gia per quella dia / In cui poteva tanto el sancto zelo / Chel decreto del cielo ad le sapria,' Palmieri [1927–8], I, 6–8.

36. Dati wrote a Latin commentary on the *Città di Vita* (it is paired with Palmieri's text in the Laurenziana codex).

37. Palmieri's notion of 'usefulness' is discussed further in Rubin 2007, p. 40.

38. See Hyatte 1994.

39. Martines 1963, p. 242.

40. Cited in Taylor 1986, p. 79.

41. In 1467 he declined a commission to Milan because of a combination of bad weather and ill health and in 1468 he refused an embassy to Lunigiana again on grounds of ill health, indicating that he was suffering from gout and could ride a horse only with difficulty and pain. In January of the following year he refused an embassy to Milan to secure the support of the Duke of Milan for the Medici regime which was again under threat. He apparently claimed that at his age (he was then 61) he was too old to travel through the mud and in the cold. A year later he would complain of his health again after returning from an embassy and he refused a third embassy because of his poor health. See Taylor 1986, pp. 83 and 138.

42. Rinuccini 1953; also reproduced in full (in Latin) in Mita Ferraro 2005, appendix.

43. See note 5.

44. '*Intelligeret autem quam multum ad uitam ciuilem cum dignitate peragendam divitiae conferrent, sua diligentia et honestis artibus ita rem auxit familiearem, ut non modo necessariis sumptibus abunde sufficeret, sed ad decus, ad gloriam, ad dignitattem augendam suppeditaret: quaod in priuatum usum magnificae extructiones et rerum immortalis Dei cultui dicatarum amplitudo testantur, cum in reliqua uita frugalitatem et ciuilem modestiam sectaretur,*' Rinuccini 1953, p. 81.

45. Document cited in Bagemihl 1996, pp. 308–9.

Chapter 2

1. See Aristotle [1961]. It was only in the early sixteenth century that this model was drastically reformed by Nicolaus Copernicus' text, *On the Revolutions of the Celestial Spheres* (*De revolutionibus orbium coelestium*) in which the Sun occupied the central position rather than the Earth. Copernicus [1978].

2. Grant 1994, p. 541; Grant 2013, pp. 436–55, esp. 447–9.

3. See Filoramo 1992 and Leclercq 1938.

4. Irenaeus says 'those who are deemed worthy of an abode in heaven shall go there, others shall enjoy the delights of paradise, and others shall possess the splendour of the city; for everywhere the Saviour shall be seen according as they who see Him shall be worthy.' See Irenaeus, *Against Heresies*, Book V, Chapter 36. On Irenaeus and notions of the Earthly and restored Jerusalem, see Copeland 2009, pp. 147–8.

5. See n. 1.

6. These include illuminations by a Florentine pupil of the painter and miniaturist Pacino da Bonaguida, in the Biblioteca Laurenziana in Florence (Laur. Strozz. 152) dating to about 1335 and a codex in Milan (Bib. Trivulziana MX. 1080), illuminated by the Florentine miniaturist known as the Master of the Dominican Effigies, dated to 1337. These are both discussed (among others) in Pope-Hennessey 1993, pp. 7ff.

7. Vasari's assertion that Palmieri provided Botticini with the '*disegno*' or design of the altarpiece is supported by documentary evidence cited by Bagemihl 1996, pp. 309, 313, doc. 1.

8. The earlier painting, which no longer survives, was painted around 1413–30 for Frate Antonio of Arezzo, a Franciscan friar who regularly gave readings from Dante in the Cathedral in this period. It appears to have been commissioned to celebrate of the second centenary of Dante's birth. See Altrocchi 1931, pp. 15–59.

9. On early views of Florence see Ciullini 1924; Boffito and Mori 1926b.

10. See discussion of the *Della Vita Civile* in Chapter 1.

11. The Cumaean Sibyl instructs the hero Aeneas how to enter the Underworld in Book VI of Virgil's *Aeneid*.

12. See *Città di Vita* I, I, 1–2 and I, II, 39 and 43, and Dati's commentary on these passages.

13. The war in Heaven between God and Lucifer is described in Revelation 12:7–13.

14. See discussion in Mita Ferraro 2005, pp. 371–2.

15. See *Città di Vita* III, XXXIII, 35–50. The long tradition of describing the Virgin as the 'Bride of Christ' derives from a Christian interpretation of the Song of Songs. The Virgin is also described as such in the New Testament in the Gospels, Revelation and, the Epistles.

16. See *Città di Vita* III, XXXIV, 23–38.

17. While Palmieri may have known Origen's original text, which was certainly circulating in Florence in this period, he may have equally relied on the long passages cited in Jerome's Epistle CXXIV *Ad Avitum* (To Avitus). See discussion in Cumbo 2006, pp. 32–4.

18. I discussed this briefly in Chapter 1 in the section on 'Palmieri's humanist studies and early writings'.

19. Marsilio Ficino refers to Origen's *Peri Archon* in chapter VII of *De Christiana Religione*, published 1476; on Origen in the Renaissance see Wind 1954 and Taylor 1986, p. 298.

20. These letters are discussed in Taylor 1986, p. 285.

21. Ibid.

22. Taylor 1986, p. 299.

23. It is unclear from Landino's account in the *Commento sopra la Commedia*, whether Palmieri himself or his poem was condemned due to accusations of heresy. See discussion in Mita Ferraro 2005, pp. 427–8.

24. Filippo writes '*cum de angelis librum conscripsisset erroribus plenum tanquam hereticus condemnatus apud coronam exustus est*' or '[Palmieri], whose book on the angels was full of errors was condemned as a heretic and was burned near coronam'. Filippo da Bergamo 1483, 275r. This account is also reported by Boffito, 1901; later mis-transcriptions of this passage led to the notion that Palmieri or his poem were burned in Cortona. See Mita Ferraro 2005, p. 430.

25. For example, Johannes Trithemius, a German humanist and theologian, suggested that the body of the poet had been burned in his *De scriptoribus ecclesisaticis…* (1494). For more on Trithemius's text see Mita Ferraro 2005, p. 432 and n. 170.

26. Gelli [1978], pp. 984–7; Gelli returns to the subject of Palmieri and his poem again in Gelli [1976], pp. 606, 651, 861–3.

27. Vasari [1966–87], vol. III, 1971, pp. 514–5.

28. Richa 1754–62, vol. I, part I, p. 155–7.

29. Bagemihl suggested that each of the figures in the celestial sphere is marked with a golden star on his or her chest, and that this was meant to suggest the angelic origin of their soul as described by Palmieri in the *Città di Vita*. A close examination of the painting reveals, however, that not all figures are inscribed with a star, throwing the earlier interpretation into doubt. Bagemihl 1996, p. 311.

30. These documents were discovered by Bagemihl. See Bagemihl 1996, p. 311.

31. In Palmieri's 'summary' of the poem (now in Modena) he makes this structure clearer than in the poem itself. Palmieri indicates that Heaven is equated with the Prime Mover, below which is the Elysian Fields which he equates with the Earthly Paradise and below Elysium are the Celestial Spheres. See Mita Ferraro 2012, pp. 105–6.

32. See for example Nardo di Cione, *Paradiso*, fresco, 1354–7 in Santa Maria Novella, Florence (fig. 64); Fra Angelico, *Fiesole Predella*, 1423–4, National Gallery, London; Giovanni di Paolo, *Last Judgement*, 1465, Pinacoteca Nazionale di Siena.

33. Vasari indicates that Brunelleschi designed these sets. For a discussion of the sacred play and its staging see Newbigin 1996; Holmes 1999, pp. 50–3, 168.

34. See for example Holmes's discussion of Lippi's fresco of the *Coronation of the Virgin* in Holmes 1999, pp. 167–8 or Plazzotta's discussion of Botticelli's *Mystic Nativity* in Plazzotta 1999.

Chapter 3

1. See Clark 1976, esp. pp. 36ff; and Casey 2002.
2. Alpers 1983, p. 124.
3. On the Piero del Massaio manuscripts and their dating see Elam 2015. See also Fischer 1932 and Levi d'Ancona 1962, pp. 220–3. See also discussions in Millar 1998, Gautier Dalché 2007 and Rombai 2007.
4. Rombai 2007.
5. Boffito and Mori 1926a, pp. xx and 12–21.
6. Hale 2007, and Rombai 2007, esp. pp. 934ff.
7. I would like to thank Amanda Lillie for these identifications, which differ from those made by Stokes 1892, p. 262.
8. In both his *Nativity* in the Church of San Lorenzo in Florence and in a *tondo* now in the collection of the Credito Bergamasco in Bergamo (fig. 38), Botticini repeats the views of Fiesole and the city of Florence with some minor changes.
9. After Romulus' death, he was venerated as the patron saint of Fiesole and the Oratory was rededicated in his name. The most comprehensive account of the Badia Fiesolana is Viti 1956.
10. On the library, see Dressen 2013.
11. We don't know when this gift was made but it may have been as early as 1466 when the Sassetti acquired the rights to their chapel at the Badia. See Nuttall 1993. On the dedication see also Viti 1956, p. 2.
12. See Nuttall 1993.
13. See Viti 1956, p. 2.
14. It was proposed by Stokes that the curious pointed form emerging from behind the flat crenellated bell tower of the Badia represents that belonging to the Church of San Domenico beyond but this cannot be correct as the tower of that nearby church was only completed in the early seventeenth century. See Stokes 1892, p. 263. On San Domenico, see Cipriani 2014, and Ferretti 1992.
15. Bargellini and Guarnieri 1977, pp. 130–2.
16. Note that this part of the old Via Fiesolana was replaced in the nineteenth century by the Via Giovanni Boccaccio. On Palmieri's acquisition of the Villa see Mita Ferraro 2005, p. 41, n. 85. Confusingly, a nearby villa, now owned by the European University, is known as the 'Villa Schifanoia'.
17. Giovanni bought the villa site at some point between 1451 and 1453, for the documents relating to the acquisition, see Lillie 1993, p. 196.
18. On Pliny's villas see Ruffinière du Prey 1994.
19. See, for example, Pliny the Younger's Epistle to Gallus 2.17 and Epistle to Apollinaris 5.6.
20. I have only been able to trace this tradition back to the nineteenth century but it probably predates the earliest written account in Bandini 1800, pp. 36–40. This association is repeated by Harold Acton (who lived nearby) in Acton 1984, p. 138.
21. Boccaccio 1921, Introduction to the Third Day of the Decameron, p. 11.
22. This has been eloquently discussed in Lillie 2007, pp. 11–55.
23. Lillie 2007, p. 12.
24. Cited by Lillie 2007, op. cit. p. 35.
25. See Klapisch-Zuber 1983.
26. Stokes 1892.
27. Giuseppe Marchini has shown that there seems to have been a villa on the site that pre-dated Scala's house as indicated by Giuseppe Poggi's plans of the villa before his nineteenth-century renovation which recorded an earlier style of carved corbel (*peduccio*) in the room immediately to the left of the main entrance, see Marchini 1950, pp. 348.
28. This villa is discussed in Lillie 2007, p. 22, n. 33.
29. See for example Jacopo Sellaio's *Saint John the Baptist* panel, around 1480, now in the National Gallery of Art, Washington, and Giovanni Toscani's early fifteenth-century cassone panel, *The Feast of Saint John the Baptist* now in the the Museo Nazionale del Bargello, Florence.
30. For the church of San Pier Maggiore see Richa 1754–62, I, pp. 124–61; Follini and Rastrelli 1709–1802, v, pp. 79–99; Paatz 1940–1952, IV, pp. 629–57; Weddle 2006, p. 396, Solberg 2007, p. 200.
31. That the Florentines saw their city as the New Jerusalem has been well demonstrated, see for example Weinstein 1968, pp. 15–44; and Earenfight 2013, pp. 131–60.
32. King 1987, pp. 275–8; for documents regarding the selling of the 'casa bianca' in 1458 see Messeri 1894, p. 273.
33. The identification of the city as Prato was made by Follini and Rastrelli 1789–1802, vol. v, p. 87 and was cautiously repeated by Davies 1961, p. 123. Davies concludes, however, that the city is so 'slightly shown' that it seems more likely to be fanciful.

Chapter 4

1. Vasari 1912, p. 249.
2. The panels, long attributed to Botticini, have only recently been associated by Laurence Kanter with a predella painted by Botticini while in Neri's workshop. Neri himself painted the main tier of the altarpiece, the *Coronation of the Virgin*, now in the Accademia, Florence. On the predella see Strehlke and Israëls [forthcoming]. I would like to thank the authors for sharing this information with me before publication.
3. Venturini 1994, p. 25.
4. The pose and physiognomy of the Archangel Michael appears particularly close to the saints in Piero del Pollaiuolo's altarpiece for the chapel of the Cardinal of Portugal in San Miniato al Monte, around 1467–8 now in the Galleria degli Uffizi, Florence.
5. Compare, for example, with the panel from San Miniato and now in the Galleria degli Uffizi and with the National Gallery's painting by Verrochio and an assistant (Lorenzo di Credi), *Virgin and Child*, 1476–8 (fig. 53).
6. Crowe and Cavalcaselle 1864–6, vol. II, p. 397.
7. Bode 1882, Berenson 1896, Schmarsow 1897. Morelli 1890–3 maintained the attribution to Botticelli. See history of attribution in Venturini 1994, p. 108, cat. no. 23, fig. 26.
8. This has been suggested by at least eight scholars from Cavalcaselle in 1896 to Venturini in 1994. For further discussion and references see Venturini 1994, p. 108.
9. As Konrad Oberhuber demonstrated, Botticini's figure of Saint Peter in the altarpiece of the *Virgin and Child with Saints*, around 1471, now at the Musée

Jaquemart-André, Paris is largely derived from the figure of Saint James from the so-called *Pala del Maglio*, around 1472–4, long attributed to Verrocchio and now widely believed to be by Biagio d'Antonio (now in the *Szépmüvészeti Múzeum*, Budapest). See Oberhuber 1978, pp. 65–6. On the drapery studies of Verrocchio and his contemporaries see Cadogan 1983, pp. 27–62.

10. Venturini 1994, no. 43; and Apfelstadt 1992.

11. The *Madonna and Child in Glory* now in the Musée du Louvre was identified, for example, as a Rosselli by Vasari in his *Vita* on the artist. See Venturini 1994, p. 121, cat. 60.

12. Davies 1961; Venturini 1999, pp. 84, 130–1, cat. 87.

13. The document is a payment to Raffaello and identifies him as 'Raphaellis Francisici Joannis botticini pictoris florentini'. Milanesi 1888, p. 110.

14. See Bode 1882 and discussion in Venturini 1994, p. 115, cat. 41.

15. Hermann Ulmann agrees with Bode that the Palmieri altarpiece cannot be by Botticelli but should be grouped with those works by the 'Master of the Pala Rossi' which Schmarsow had suggested should be identified with Francesco Botticini; see Ulmann 1893. Schmarsow published this opinion in 1897 but claims to have published an essay on the subject in 1887. Although the present author has been unable to verify this, Ulmann seems to corroborate Schmarsow's claim.

16. See Schmarsow 1897.

17. Berenson 1900, Berenson 1909.

18. Although Horne never published a book on Botticini, nor does he even appear to have begun writing one, his research notes, now preserved in the Archivio della Fondazione Horne, Florence, suggest that he was collecting information on the artist to this end; Berenson published the attribution of the illuminations to Botticini in Berenson 1903.

19. See London 1882, p. 58, lot 417.

20. Bandini 1800, p. 80 says that after the destruction of the church, the picture was transferred to Casa Palmieri; Harold Acton (1904–94) who knew Villa Palmieri and its inhabitants well and lived nearby, indicates that Botticini's *Assumption* was brought to the villa and walled up but doesn't provide a source for this claim. See Acton 1984, p. 184.

21. On the selling of the house see Paolozzi Strozzi 2008, p. 78.

22. This is recounted in an undated memo in the Hamilton Palace Papers (F2/1069).

I would like to thank Nicholas Penny for providing me with this information.

23. A certain 'Mr Kirkup' is said to have seen the painting when it was with Riccieri. Kirkup told the story to Robert Browning who told the director of the National Gallery, Sir Frederick Burton, on 6 October 1884. See document in National Gallery archives. For a further discussion of the provenance see Davies 1961, p. 124.

24. Davies, following Kirkkup's account as reported to Burton (see note above) indicates that Woodburn bought the work in Paris in 1846, this appears to be a confused record as the Hamilton Palace Papers indicate that Woodburn bought the work in Florence in 1844.

25. On Woodburn's acquisition of the panel from an unspecified dealer located (located between the Piazza degli Antinori and Hotel New York in Florence) see the Hamilton Palace Papers (F2/1069). On Woodburn's attempts to sell these works to the National Gallery see S. Avery-Quash, 'The Growth of Interest in Early Italian Painting in Britain' in Gordon 2003, pp. XXV–XXLIV.

26. See Hamilton Palace Papers F2/1069 no. 41; C4/843A. Interestingly, the Duke had already acquired Sandro Botticelli's famous drawings for Dante's *Divine Comedy*, executed between about 1480 and 1495, by 1819. On Dante's drawings see Schulze Altcappenberg 2001, esp. pp. 20–1 on provenance and commission.

27. Waagen 1854, p. 296.

28. See London 1882, p. 58, lot 417.

29. These documents were first published and discussed by Bagemihl 1996.

30. See Bagemihl 1996.

31. It is unlikely that she wears the Benedictine habit as suggested in Davies 1961, p. 123, and Bagemihl 1996, p. 309. Botticini portrays widow patrons in several of his works in widow's weeds. See for example, Pippa Capacci, a widow portrayed in the *Tabernacle of Saint Sebastian* (fig. 63).

32. These sources are mentioned in Chapter 1. See Gamurrini 1668–85 vol. III, p. 109 and Richa 1754–62, vol. I, p. 147.

33. This is clear from the eighteenth-century plan and elevation drawings of the church preserved in the State Archives of Prague, Chiese della città di Firenze, Archivio di Familglia degli Asburgo in Toscanan, Inv. VII. 2/6, vol. 2 (Cabrei) (fig. 17).

34. Paatz for example describes the Palmieri chapel under the nuns' choir which they mistakenly locate in the south transept.

Paatz 1940–54, vol. IV, p. 638. Similarly Follini and Rastrelli imply that the Palmieri chapel was located under the nuns' choir; Follini and Rastrelli 1789–1802, vol. V, p. 87.

35. See a transcription and further discussion of the documents relating to the chapel in Bagemihl 1996.

36. See Bagemihl 1996.

Angelic Hierarchies and Identifying the Saints

1. A helpful and accessible overview of these models is found in Gill 2014.

2. *Città di Vita*, I, VII, 26–9, 31–2, 34, 36–41, 44; III, XXXIV, 25–30.

3. Although traditionally the archangels are believed to number only three or seven, the orthodox tradition describes thousands of archangels, as for example in the Divine Liturgy of St John Chrysostom. Although Botticini depicts more than seven archangels, the vessels that these figures hold evoke the seven bowls containing seven plagues held by seven angels as described in Revelation 21:9.

4. *Città di Vita*, III, XXXII, 21–34.

5. *Città di Vita*, III, XXXIII, 35–43.

6. *Città di Vita*, III, XXXII, 35–41. It is also worth noting that a small apocryphal book on the *Assumption of the Virgin* is attributed to John the Evangelist.

7. In Jacopo di Cione's altarpiece for San Pier Maggiore the Saint Benedict wears black. The Saint usually only wears white robes in paintings for the reformed Benedictines such as for Camaldolese, Olivetan or Cistercian Orders who all followed Benedictine Rule. Artists such as Fra Angelico, Luca Signorelli and Pintorichio for example all change the colour of the Saint's habit to reflect the patrons or context of their work; see Boccolini 1959. If the altarpiece was indeed made for Palmieri's chapel in the Badia Fiesolana, as argued in Nuttall 1993, the colour of Benedict's robes may reflect the Camaldolese origins of this church.

8. Compare for example with the portrait of Pope Paul II on the medal by Cristoforo di Geremia, around 1464–71 or the marble bust by the workshop of Paolo Romano in the Museo di Piazza Venezia of around 1464–71.

Bibliography

ACTON 1984

H. Acton, *The Villas of Tuscany*, London 1984

ALPERS 1983

S. Alpers, *The Art of Describing: Dutch Art in the Seventeenth Century*, Chicago 1983

ALTROCCHI 1931

R. Altrocchi, 'Michelino's Dante', *Speculum* 6:1, 1931, pp. 15–59

APFELSTADT 1992

E.C. Apfelstadt, 'A new context and a new chronology for Antonio Rossellino's statue of St Sebastian in Empoli' in *Verrocchio and Late Quattrocento Italian Sculpture*, Florence 1992, pp. 189–203

ARTISTOTLE [1961]

Artistotle, *The Metaphysics*, books I–IX, with an English trans. by H. Tredennick, The Loeb classical library, London 1961

BAGEMIHL 1996

R. Bagemihl, 'Francesco Botticini's Palmieri Altar-Piece', *The Burlington Magazine*, vol. 138, no. 1118, May 1996, pp. 308–14

BANDINI 1800

A.M. Bandini, *Lettere XII. ad un amico, nelle quali si ricerca, e s'illustra l'antica e moderna situazione della città di Fiesole e dei suoi contorni*, Siena 1800

BARGELLINI AND GUARNIERI 1977

P. Bargellini and E. Guarnieri, *Le Strade di Firenze*, Florence 1977

BERENSON 1896

B. Berenson, *The Florentine Painters of the Renaissance*, New York and London 1896

BERENSON 1900

B. Berenson, *The Florentine Painters of the Renaissance*, New York and London 1900

BERENSON 1903

B. Berenson, *The Drawings of the Florentine Artists*, London 1903

BERENSON 1909

B. Berenson, *The Florentine Painters of the Renaissance*, New York and London 1909

BOCCACCIO 1921

G. Boccaccio, *Decameron*, J.M. Rigg, Trans. London, 1921

BOCCACCIO [1952]

G. Boccaccio, *Decameron*, eds E. Bianchi, C. Salinari and N. Sapegno, Milano–Napoli 1952

BOCCOLINI 1959

I. Boccolini, *La figura di San Benedetto nell'arte Italiana*, Rome 1959

BODE 1882

W. von Bode, 'Die italienishcen Skulpturen der Renaissance in der Königlichen Museen, II. Bildwerke des Andrea del Verrocchio', *Jahrbuch der königlich Preussischen Kunstsammlungen,* vol. III, 1882, pp. 235, 267

BOFFITO 1901

G. Boffito, 'L'eresia di Matteo Palmieri, "Cittadino Fiorentino",' *Giornale storico della Letteratura Italiana, XXXVII* (1901), pp. 1–69

BOFFITO AND MORI 1926A

G. Boffito and A. Mori, *Piante e vedute di Firenze, studio storico topografico cartografico*, Florence 1926

BOFFITO AND MORI 1926B

A. Mori and G. Boffito, *Firenze nelle vedute e piante*, Florence 1926

BONSIGNORI AND RAGIONIERI 1969

I. Bonsignori and A. Ragionieri, *Itinerario farmaceutico di Firenze*, Milan 1969

CADOGAN 1983

J.K. Cadogan, 'Linen Drapery Studies by Verrocchio, Leonardo and Ghirlandaio' in *Zeitschrift für Kunstgeschichte* 46. Bd., H. 1, 1983, pp. 27–62

CARPETTO 1984

G. Carpetto, *The Humanism of Matteo Palmieri*, Rome 1984

CASEY 2002

E.S. Casey, *Representing Place: Landscape Painting and Maps*, Minneapolis 2002

CAVALCANTI 1839

G. Cavalcanti, *Istorie fiorentine* [1420–47], ed. F.L. Polidor, Florence 1839

CIASCA 1927
R. Ciasca, *L'arte dei medici e speziali nella storia e nel commercio fiorentino dal secolo XII al XV*, Florence 1927

CIPRIANI 2014
M. Cipriani, *San Domenico di Fiesole storia e arte*, Florence 2014

CIULLINI 1924
R. Ciullini, 'Raccolta di antiche carte e vedute della città di Firenze' in *L'universo* VL, 8 August 1924

CLARK 1976
K. Clark, *Landscape into Art*, London 1976

COPELAND 2009
K.B. Copeland, 'The Earthly Monastery and the Transformation of the Heavenly City in Late Antique Egypt' in *Heavenly Realms and Earthly Realities in Late Antique Religions*, eds R.S. Boustan and A. Yoshiko Reed, Cambridge 2009, pp. 142–58

COPERNICUS [1978]
N. Copernicus, *On the Revolutions*, ed. J. Dobrzycki, trans. E. Rosen, London 1978

CROWE AND CAVALCASELLE 1864–6
J.A. Crowe and G.B. Cavalcaselle, *A New History of Painting in Italy from the Second to the Sixteenth Century*, 3 vols, London 1864–6

CUMBO 2006
B. Cumbo, *La Città di vita di Matteo Palmieri: ipotesi su una fonte quattrocentesca per gli affreschi di Michelangelo nella volta Sistina*, Palermo 2006

DAVIES 1961
M. Davies, *National Gallery Catalogues, The Earlier Italian Schools*, London 1961

DRESSEN 2013
A. Dressen, *The Library of the Badia Fiesolana. Intellectual History and Education under the Medici (1462–1494)*, Florence 2013

EARENFIGHT 2013
P. Earenfight, '"Civitas Florenti[a]e": the New Jerusalem and the Allegory of Divine Misericordia', in *A Scarlet Renaissance: Essays in Honour of Sarah Blake McHam*, ed. A.V. Coonin, New York 2013, pp. 131–60

ELAM 2015
C. Elam, 'Painter, mapmaker and military surveyor', Mitteilungen des Kunsthistorischen Institutes in Florenz', Band LVII, 2015, Heft I, pp. 65–89

FERRETTI 1992
L. Ferretti, *La chiesa e il convento di San Domenico di Fiesole: monografia illustrata*, Siena 1992

FILIPPO DA BERGAMO 1483
Filippo da Bergamo, *Supplementum Chronicarum*, Venice 1483

FILORAMO 1992
G. Filoramo, 'Paradise' in *The Encyclopedia of the Early Church*, ed. A. di Berardino, trans. A. Walford, Vol. II, Cambridge 1992

FISCHER 1932
J. Fischer, *Claudii Plotemaei, Geographiae Codex Urbinas Graecus 82*, 3 vols, Brill 1932

FOLLINI AND RASTRELLI 1789–1802
V. Follini and M. Rastrelli, *Firenze antica, e moderna illustrata*, 8 vols, Florence 1789–1802

GAMURRINI 1668–85
D.E. Gamurrini, *Istoria genealogica delle famiglie nobili toscane et umbre, descritta da D. Eugenio Gamurrini, Abate Cassinense, Nobile Aretino*, 5 vols, Florence 1668–85

GAUTIER DALCHÉ 2007
P. Gautier Dalché, 'The Reception of Ptolemy's Geography' (End of the Fourteenth to Beginning of the Sixteenth Century), *The History of Cartography*, ed. David Woodward, vol. 3, Part I, 2007, pp. 285–364

GELLI [1976]
G.B. Gelli, *Letture sopra la Commedia di Dante* (1551), ed. D. Maestri, Turin 1976

GELLI [1978]
G.B. Gelli, 'I Capricci del Bottaio (1548)' in *I Trattatisti del Cinquecento*, ed. Mario Pozzi, Milan 1978, pp. 851–1205

GILL 2014
M.J. Gill, *Angels and the Order of Heaven in Medieval and Renaissance Italy*, Cambridge 2014

GOLDTHWAITE 1980
R. Goldthwaite, *The Building of Renaissance Florence: An Economic and Social History*, Baltimore 1980

GORDON 2003
D. Gordon, *The Fifteenth Century Paintings: National Gallery Catalogues*, Vol. I, London 2003

GRANT 1994
E. Grant, *Planets, Stars, and Orbs: The Medieval Cosmos, 1200–1687*, Cambridge 1994

GRANT 2013
E. Grant, 'Cosmology' in *The Cambridge History of Science: Volume 2, Medieval Science*, eds D.C. Lindberg and M.H. Shank, Cambridge 2013, pp. 439–58

GREENSTEIN 1992
J.M. Greenstein, *Mantegna and Painting as Historical Narrative*, Chicago and London 1992

HALE 2007
J. Hale, 'Warfare and Cartography, c. 1450 to c. 1640' in *The History of Cartography*, ed. D. Woodward, vol. 3, Part I, 2007, pp. 719–37

HOLMES 1999
M. Holmes, *Fra Filippo Lippi the Carmelite Painter*, New Haven and London 1999

HYATTE 1994
R. Hyatte, *The Arts of Friendship: The Idealization of Friendship in Medieval and Early Renaissance Literature*, Leiden 1994

KING 1987
C. King, 'The Dowry Farms of Niccolosa Serragli and the Altarpiece of the Assumption in the National Gallery London (1126) Ascribed to Francesco Botticini', *Zeitschrift für Kunstgeschichte* 50. Bd., H. 2, 1987, pp. 275–8

KLAPISCH-ZUBER 1983
C. Klapisch-Zuber, *Una carta del popolamento Toscano negli anni 1427–1430*, Milan 1983

LECLERCQ 1938
H. Leclercq, 'Paradis' in *Dictionnaire d'archéologie d'art chrétienne et de liturgie*, Paris 1938

LEVI D'ANCONA 1962
M. Levi d'Ancona, *Miniatura e miniatori a Firenze dal XIV al XVI secolo*, Florence 1962

LILLIE 1993
A. Lillie, 'Giovanni di Cosimo and the Villa Medici at Fiesole', in eds A. Beyer and B. Boucher, *Piero de' Medici 'il Gottoso' (1416–1469)*, Berlin 1993, pp. 189–205

LILLIE 2007
A. Lillie, 'Fiesole: *Locus amoenus* or Penitential Landscape?' in *I Tatti Studies: Essays in the Renaissance*, vol. II, 2007, pp. 11–55

LONDON 1882
The Hamilton Palace Collection: Illustrated Priced Catalogue, London 1882

LUDWIG JANSEN 2001
K. Ludwig Jansen, *The Making of the Magdalen*, Princeton 2001

MARCHINI 1950
G. Marchini, 'Aggiunte a Giuliano da Sangallo', *Commentari*, vol. I, 1950, pp. 34–8

MARTINES 1963
L. Martines, *The Social World of the Florentine Humanists, 1390–1460*, London 1963

MESSERI 1894
A. Messeri, *Matteo Palmieri: cittadino di Firenze del secolo XV*, Florence 1894

MILANESI 1888
G. Milanesi, 'Documenti inediti dell'arte toscana dal XII al XVI secolo', *Il Buonarroti*, XIX, s. III, vol. III. quad. IV. June, 1888, pp. 105–13

MILLAR 1998
N. Millar, 'Mapping the City: Ptolemy's Geography in the Renaissance' in *Envisioning the City: Six Studies in Urban Cartography*, ed. D. Buisseret, Chicago 1998, pp. 34–74

MITA FERRARO 2005
A. Mita Ferraro, *Matteo Palmieri: una biografia intellettuale*, Genoa 2005

MITA FERRARO 2012

A. Mita Ferraro, *Senza aver penne non si può volare. Un sommario della 'Città di vita' di Matteo Palmieri*, Florence 2012

MORELLI [1393–1411, 1421]

G. Morelli, *Ricordi*, codex Magliabechiano II. IV. 52, Biblioteca Nazionale di Firenze [1393–1411, 1421]

MORELLI 1890–3

G. Morelli, *Kunstkritische Studien über italienische Malerei*, Leipzig 1890–3

NEWBIGIN 1996

N. Newbigin, *Feste d'Oltrarno. Plays in Churches in Fifteenth-Century Florence*, 2 vols, Istituto Nazionale di Studi sul Rinascimento, Florence 1996

NUTTALL 1993

P. Nuttall, 'The Patrons of Chapels at the Badia of Fiesole', *Studi di Storia dell'Arte*, 3, 1993, pp. 97–112

OBERHUBER 1978

K. Oberhuber, 'Le problème des premières oeuvres de Verrocchio', *Revue de l'Art* XXXXII, 1978, pp. 63–76

PAATZ 1940–54

W. and E. Paatz, *Die Kirchen von Florenz ein kunstgeschichtliches Handbuch*, 6 vols, Frankfurt am Main 1940–54

PALMIERI [1717]

M. Palmieri, 'Elogio di Carlo Marsuppini,' in *Fasti consolari dell' Accademia Fiorentina*, ed. S. Salvini, Florence 1717, pp. 525–7

PALMIERI [1927–8]

M. Palmieri, *Libro del poema chiamato Citta di vita composto da Matteo Palmieri Florentino*, transcribed from the Laurentian ms XL 53 and compared with the Magliabechian II ii 41, M. Rooke, pref., Northampton 1927–8

PALMIERI [1982]

M. Palmieri, *Della Vita Civile*, ed. G. Belloni, Florence 1982

PALMIERI [1983]

M. Palmieri, *Libro di Ricordi di portate et altre memorie diverse di messere Matteo di Marco Palmieri*, ed. E. Conti, in *Ricordi fiscali (1427–1474)*, Rome 1983

PAOLOZZI STROZZI 2008

B. Paolozzi Strozzi, 'Dannato e danneggiato? Ipotesi (e notizie) attorno al busto di Matteo Palmieri di Antonio Rossellino' in *Governare L'Arte: scritti per Antonio Paolucci dalle Soprintendenze Fiorentine*, Florence 2008, pp. 75–81

PLAZZOTTA 1999

C. Plazzotta, *Kingdom Come, Botticelli's Mystic Nativity*, brochure, London 1999

POPE-HENNESSEY 1993

J. Pope-Hennessey, *Paradiso: The Illuminations of Dante's Divine Comedy by Giovanni di Paolo*, London 1993

RICHA 1754–62

G. Richa, *Notizie Istoriche delle Chiese fiorentine*, 10 vols, Florence 1754–62 (reprint, Rome 1989)

RINUCCINI 1953

A. Rinuccini, *Lettere ed orazioni*, ed. V.R. Giustiniani, Florence 1953

ROCCHIETTA 1986

S. Rocchietta, *Antichi vasi di farmacia italiani*, Milan 1986

ROMBAI 2007

L. Rombai, 'Cartography in the Central Italian States from 1480 to 1680' in *The History of Cartography*, ed. D. Woodward, vol. 3, Part 1, 2007, pp. 909–39

RUBIN 2007

P.L. Rubin, *Images and Identity in Fifteenth-Century Florence*, New Haven and London 2007

RUBINSTEIN 1966

N. Rubinstein, *The Government of Florence Under the Medici (1434 to 1494)*, Oxford 1966

RUFFINIÈRE DU PREY 1994

P. de la Ruffinière du Prey, *The Villas of Pliny from Antiquity to Posterity*, Chicago–London 1994

SCHMARSOW 1897

A. Schmarsow, 'Florentiner Studien, Italiensische Studien in anderen Sammlungen' in *Festschrift zu Ehren des Kunsthistorischen Instituts in Florenz*, Leipzig 1897

SCHULZE ALTCAPPENBERG 2001

H.-Th. Schulze Altcappenberg, *Sandro Botticelli: The Drawings for Dante's Divine Comedy*, Exh. Cat., Royal Academy of Arts, London 2001

SHAW AND WELCH 2011

J. Shaw and E. Welch, *Making and Marketing Medicine in Renaissance Florence*, Amsterdam 2011

SOLBERG 2007

G.E. Solberg, 'Bild und Zeremoniell in San Pier Maggiore, Florenz' in *Zeremoniell und Raum in der frühen italienischen Malerei*, ed. S. Weppelmann, Berlin 2007, pp. 194–209

STOKES 1892

M. Stokes, *Six Months in the Apennines or A Pilgrimage in Search of the Vestiges of the Irish Saints in Italy*, London 1892

STREHLKE AND ISRAËLS [FORTHCOMING]

C.B. Strehlke and M. Israëls, eds, *Catalogue of the European Paintings, Villa I Tatti, The Harvard University Center for Italian Renaissance Studies*, Cambridge, Mass. [forthcoming]

TAYLOR 1986

M. Taylor, *Matteo Palmieri (1406–1475): Florentine Humanist and Politician*, Thesis (doctoral), European University Institute, Florence 1986

ULMANN 1893

H. Ulmann, *Sandro Botticelli*, Munich 1893

VASARI [1912]

G. Vasari, *Lives of the Most Eminent Painters, Sculptors and Architects*, trans. by Gaston du C. De Vere, 10 vols, London 1912

VASARI [1966–87]

G. Vasari, *Le Vite de' più eccellenti pittori scultori e architettori nelle redazioni del 1550 e 1568*, eds R. Bettarini and P. Barocchi, 6 vols, Florence 1966–87

VENTURINI 1994

L. Venturini, *Francesco Botticini*, Florence 1994

VESPASIANO DA BISTICCI [1970–7]

Vespasiano da Bisticci, *Le Vite [di uomini illustri del secolo XV scritte da Vespasiano da Bisticci]*, ed. Aulo Greco, 2 vols, Florence 1970–7

VITI 1956

P.V. Viti, *La Badia Fiesolana*, Florence 1956

WAAGEN 1854

G. Waagen, *Treasures of Art in Great Britain*, 3 vols, London 1854–7

WEDDLE 2006

S. Weddle, 'Identity and Alliance: Urban Presence, Spatial Privilege, and Florentine Renaissance Convents,' in *Renaissance Florence: A Social History*, eds R.J. Crum and J.T. Paoletti, New York 2006, pp. 394–414

WEINSTEIN 1968

D. Weinstein, 'The Myth of Florence,' in *Florentine Studies: Politics and Society in Renaissance Florence*, ed. Nicolai Rubinstein, Evanston 1968

WIND 1954

E. Wind, 'The Revival of Origen' in *Studies in Art and Literature for Belle Da Costa Greene*, ed. D. Milner, Princeton 1954, pp. 412–24

Lenders

Photographic Credits

Lenders

ITALY

Bergamo

Accademia Carrara di Belle Arti Bergamo
Credito Bergamasco – Gruppo Banco
 Popolare

Florence

Biblioteca Medicea Laurenziana
Museo Nazionale del Bargello

Venice

Galleria Giorgio Franchetti alla Ca' d'Oro

SWEDEN

Stockholm

Nationalmuseum

UNITED KINGDOM

London

The British Library
The British Museum
The Victoria and Albert Museum
The Warburg Institute
The Wellcome Trust

UNITED STATES

New York

The Metropolitan Museum of Art
The Robert Lehman Collection

and those private collectors who
wish to remain anonymous.

Photographic Credits

All images © The National Gallery, London, unless credited otherwise below. All numbers below refer to figure numbers.

BERGAMO © Accademia Carrara, Bergamo: 55; Collezione Credito Bergamasco – Gruppo Banco Popolare © Photo courtesy of the owner: 38, 51.

BERLIN Kupferstichkabinett, Staatliche Museen zu Berlin-Preussischer Kulturbesitz © DeAgostini Picture Library / Scala, Florence: 23; Skulpturensammlung, Staatliche Museen zu Berlin-Preussischer Kulturbesitz © Photo Scala, Florence / bpk bildagentur für Kunst, Kultur und Geschichte, Berlin. Photo: Jörg P. Anders: 12.

BOLOGNA Biblioteca universitaria, Bologna © Photo Scala, Florence: 6.

EMPOLI Pinacoteca museo della Collegiata di Sant'Andrea, Empoli © Photo Jennifer Sliwka: 63.

FLORENCE Alinari Archives © Mary Evans / Alinari Archives: 8; Biblioteca Medicea Laurenziana, Florence © Su concessione del Ministero per i Beni e le Attività Culturali: 10, 26, 27, 28, 29, 30, 31; Cathedral of Santa Maria del Fiore, Florence © Photo Scala, Florence: 22; Galleria degli Uffizi, Florence © Photo Scala, Florence – courtesy of the Ministero Beni e Att. Culturali: 44; Museo Nazionale del Bargello, Florence © Photo Scala, Florence – courtesy of the Ministero Beni e Att. Culturali: 1, 16; Museo storico topografico di Firenze com'era, Florence © Photo Scala, Florence: 15, 37; © Photo Miguel Santa Clara: 9, 42; Santa Maria Novella, Florence © Photo Scala, Florence / Fondo Edifici di Culto – Min. dell'Interno: 64.

LONDON © akg-images / Erich Lessing: 14; © The Trustees of The British Museum: 7, 24, 41; © By Permission of The British Library, London: 20, 21; Victoria and Albert Museum, London © V&A Images / Victoria and Albert Museum, London: 13.

NEW YORK © The Metropolitan Museum of Art, New York: 18, 19, 50.

PARIS Musée du Louvre, Paris © Photo Scala, Florence: 54.

PRAGUE © National Archives Prague: 17.

PRIVATE COLLECTION © Photo The Fitzwilliam Museum, Cambridge: 36.

STOCKHOLM © Photo Nationalmuseum, Stockholm: 57, 59.

VATICAN CITY, ROME © Copyright of the Vatican Library (Biblioteca Apostolica Vaticana): 35.

VENICE Galleria Giorgio Franchetti alla Ca' d'Oro, Venice © Su concessione del Ministero dei beni e delle attività culturali e del turismo: 52.

List of Exhibited Works

FRANCESCO BOTTICINI
*The Assumption of
the Virgin*, 1475–7
Tempera on wood
228.6 × 377.2 cm
The National Gallery, London
Bought, 1882
(NG1126) Fig. 2

ANTONIO ROSSELLINO
Matteo Palmieri, 1468
Marble
54 × 60 × 30 cm
Museo Nazionale del Bargello,
Florence
(58) Fig. 1

MATTEO PALMIERI
Liber de temporibus, 1469
Vellum
28.5 × 20.5 cm
Wellcome Library, London
(MS591) Not illustrated

MATTEO PALMIERI
*Libro della vita civile / composta
da Mattheo Palmieri cittadino
Fiorentino*, 1529
Printed book on paper, vellum
binding
15.2 × 10.3 cm
Warburg Institute Library
(DPH 167) Not illustrated

MATTEO PALMIERI
La Città di Vita, about 1473
Vellum manuscript
43 × 30.5 × 8.5 cm
Biblioteca Medicea
Laurenziana, Florence
(Pluteo XL 53) Figs 10, 26–31

GIOVANNI DI PAOLO AND
PRIAMO DELLA QUERCIA
(illuminators)
La Divinia Commedia, about
1444–50
Manuscript
36.5 × 25.8 cm
The British Library
(Yates Thompson MS 36)
Figs 20–21

PISANELLO
*Medal of Alfonso V,
King of Naples*, 1449
Bronze
11.1 cm diameter
The Victoria and Albert
Museum
(2380-1855) Fig. 13

Workshop of the Astericks
(GIUNTA DI TUGIO?), Florence
Apothecary storage jar,
about 1420–50
Earthenware
Height 35.4 cm
The Trustees of The British
Museum
(1903,0515.1) Not illustrated

Albarello (apothecary
storage jar), about 1448–51
Earthenware, 35.2 × 15 cm
The Trustees of The British
Museum
(1898,0523.1) Fig. 7

JACOPO DI CIONE
and Workshop
The San Pier Maggiore
Altarpiece, 1370–1
Egg tempera on wood
The National Gallery, London
Bought, 1857
(NG569. 1–3 and NG570–8)
Not illustrated

Main tier, central panel
The Coronation of the Virgin
206.5 × 113.5 cm
(NG569.1)

Main tier, left panel
Adoring Saints
169 × 113 cm
(NG569.2)

Main tier, right panel
Adoring Saints
169 × 113 cm
(NG569.3)

Central pinnacle panel
The Trinity
89.2 × 40 cm
(NG570)

Left pinnacle panel
*Seraphim, Cherubim
and Adoring Angels*
89.4 × 37.8 cm
(NG571)

Right pinnacle panel
*Seraphim, Cherubim and Adoring
Angels*
89.7 × 37.8 cm
(NG572)

Upper tier panel
*The Nativity with the
Annunciation to the
Shepherds and the Adoration
of the Shepherds*
95.5 × 49.4 cm
(NG573)

Upper tier panel
The Adoration of the Kings
95.5 × 49.3 cm
(NG574)

Upper tier panel
The Resurrection
95.3 × 49 cm
(NG575)

Upper tier panel
*The Three Marys at the
Sepulchre*
95.6 × 49.1 cm
(NG576)

Upper tier panel
The Ascension
95.5 × 49 cm
(NG577)

Upper tier panel
Pentecost
96 × 49.5 cm
(NG578)

Probably FRA ANGELICO
*Christ Glorified in the Court
of Heaven*
The high altarpiece for the
church of San Domenico,
Florence, about 1423–4
Egg tempera on wood
The National Gallery, London
Bought, 1860
(NG663.1–5) Not illustrated

Central panel
*Christ Glorified in the
Court of Heaven*
31.7 × 73 cm
(NG663.1)

Inner left panel
*The Virgin Mary with the
Apostles and Other Saints*
32 × 64 cm
(NG663.2)

Inner right panel
*The Forerunners of Christ
with Saints and Martyrs*
31.9 × 63.5 cm
(NG663.3)

Outer left panel
The Dominican Blessed
31.8 × 21.9 cm
(NG663.4)

Outer right panel
The Dominican Blessed
31.6 × 21.9 cm
(NG663.5)

ANDREA DEL VERROCCHIO
and assistant (Lorenzo di Credi)
*The Virgin and Child with
Two Angels*, about 1476–8
Egg tempera on wood
96.5 × 70.5 cm
The National Gallery, London
Bought, 1857
(NG296) Fig. 53

Workshop of
ANDREA DEL VERROCCHIO
Tobias and the Angel, about 1470–5
Tempera on wood
83.6 × 66 cm
The National Gallery, London
Bought, 1867
(NG781) Fig. 56

PIERO DEL POLLAIUOLO
Apollo and Daphne, probably
1470–80
Oil on wood
29.5 × 20 cm
The National Gallery, London
Wynn Ellis Bequest, 1876
(NG928) Fig. 45

SANDRO BOTTICELLI
Three Miracles of Saint Zenobius,
about 1500
Tempera on wood
64.8 × 139.7 cm
The National Gallery, London
Mond Bequest, 1924
(NG3919) Not illustrated

SANDRO BOTTICELLI
*Saint Francis of Assisi with
Angels*, about 1475–80
Tempera and oil on wood
49.5 × 31.8 cm
The National Gallery, London
Bought, 1858
(NG598) Fig. 48

CARLO CRIVELLI
Saint Michael, about 1476
Tempera on poplar
90.5 × 26.5 cm
The National Gallery, London
Bought, 1868
(NG788.11) Not illustrated

BRONZINO
*Portrait of Piero de' Medici ('The
Gouty')*, probably about 1550–70
Oil on wood
58.4 × 45.1 cm
The National Gallery, London
Bequeathed by Sir W.R. Drake,
1891
(NG1323) Not illustrated

Possibly by
FRANCESCO BOTTICINI
The Crucifixion, about 1471
Tempera on wood
28.5 × 35 cm
The National Gallery, London
Bought, 1883
(NG1138) Fig. 47

FRANCESCO BOTTICINI
*The Virgin adoring the Christ
Child*, about 1475–80
Tempera on wood
106.5 cm diameter
Collezione Credito Bergamasco
– Gruppo Banco Popolare
(CB-0005701) Figs 38 and 51

FRANCESCO BOTTICINI
*The Virgin adoring the
Christ Child*, about 1475–80
Tempera on wood
88 × 57 cm
Polo Museale del Veneto –
Galleria Giorgio Franchetti
alla Ca' d'Oro
(cat. d. 84) Fig. 52

FRANCESCO BOTTICINI
Archangel Raphael and Tobias,
about 1480
Tempera on wood
54 × 40 cm
Accademia Carrara, Bergamo
(930–1891) Fig. 55

FRANCESCO BOTTICINI
*Christ blessing the Kneeling
Virgin. Two Angels*, about 1475
Pen and brown ink
11.2 × 16.3 cm
Nationalmuseum, Stockholm
(NMH 102 / 1863) Fig. 59

Acknowledgements

This study is greatly indebted to Alessandra Mita Ferraro and Matthew Taylor's scholarship on Palmieri, Rolf Bagemihl's archival research on the *Assumption* altarpiece and Lisa Venturini's monograph on Botticini. The preparation of this catalogue has also benefited from the knowledgeable staff and invaluable resources at the Warburg and the Courtauld Institutes in London, and the Kunsthistorisches Institut and the Archivio di Stato, in Florence. For their insight into, and enthusiasm for, various aspects of this project I would especially like to thank Nicholas Penny, Caroline Campbell, Amanda Lillie and Caroline Elam. I am thankful to the institutions who have generously lent to this exhibition and to the directors, curators and conservators of those collections who facilitated my visits to study their works of art.

I would also like to express my gratitude to those individuals who assisted me with special access to objects, information and expertise: Paul Ackroyd, Susanna Agostini, Dita Amory, Philip Attwood, Andrea Bayer, Maria Benelli, Rachel Billinge, Alison Brown, Carla Calisi, Riccardo Camporesi, Keith Christiansen, Ilaria Ciseri, Andrea Clarke, Claudia Cremonini, Glyn Davies, Marion Davies, Ana Debenedetti, Rembrandt Duits, Mark Evans, Simone Facchinetti, Oscar Fini, Carina Fryklund, Arturo Galansino, Elena Greer, Mari Griffith, Gill Hart, Philippa Hemsley, Machtelt Israëls, Laurence Kanter, Robin Kiang, Larry Keith, Jane Knowles, Alta Macadam, Giorgia Mancini, Marino Marini, Susanne Meurer, Andrea Misuri, Roberta Mottola, Jonathan Nelson, Scott Nethersole, Paula Nuttall, Harriet O'Neill, Patrick O'Sullivan, David Orme, Daniela Parenti, Chiara Perfetti, Belinda Phillpot, Angelo Piazzoli, Ben Quash, François Quiviger, Ida Giovanna Rao, Maria Vittoria Rimbotti, Maria Cristina Rodeschini, Patricia Rubin, Xavier Salomon, Lois Salter, Peter Schade, Arnika Schmidt, Francesca Sidhu, Nathaniel Silver, Rocco Simone, Marika Spring, Carl Strehlke, Luke Syson, Dora Thornton, Letizia Treves, Sarah Vowles, Matthias Wivel and Alison Wright.

I would like to thank Suzanne Bosman, Rachel Giles, Jan Green, Adrian Hunt and Emily Winter who transformed my text into this beautiful catalogue and Rickie Burman, Ursula Faure-Romanelli, Judith Kerr, Susie Murphy and Amy Spolton in the Development Department of the National Gallery for all of their energy and enthusiasm for this project. My gratitude also goes to Joanne Allen, Monica Bietti, Donal Cooper, François Penz and Miguel Santa Clara for their invaluable help in creating the virtual reconstruction of the former church of San Pier Maggiore that accompanies this exhibition which was generously supported by grants from the Samuel H. Kress Foundation and from the University of Cambridge. For their constant encouragement and support, I would like to thank Ryszard, Anne and Daniel Sliwka and Philippe Piessens. The research for, and publication of, this book was made possible through the generous support of Howard and Roberta Ahmanson to whom I would like to express my deepest gratitude.

FRANCESCO BOTTICINI
Christ giving his Blessing,
about 1475
Pen and brown ink
18.5 × 11 cm
Nationalmuseum, Stockholm
(NMH 43/1863) Fig. 57

FRANCESCO BOTTICINI?
(or Alesso Baldovinetti?)
A Seated Saint reading from a Book,
late 15th century
Brush and brown ink, brown
wash, heightened with white,
pricked for transfer
26.1 × 16.2 cm
Lent by The Metropolitan of
Art, New York, Robert Lehman
Collection 1975
(1975.1.409) Fig. 50

GIOVANNI DI PAOLO
Paradise, 1445
Tempera and gold on canvas,
transferred from wood
47 × 40.6 cm
Lent by The Metropolitan
Museum of Art, Rogers Fund,
1906
(06.1046) Fig. 19

Attributed to BACCIO BALDINI
Tiburtine Sibyl, about 1470–80
Engraving
17.9 × 10.8 cm
The Trustees of The British
Museum
(1895,0915.62) Fig. 24

Workshop of FRANCESCO DI
LORENZO ROSSELLI
View of Florence, around 1500
Oil on panel
95.2 × 143.5 cm
Private collection
Fig. 36

GIUSEPPE ZOCCHI
*View of the Church and Piazza
of San Pier Maggiore*
1754 (1754 Bouchard reprint of the
1744 plate)
Etching with engraving
62.5 × 80 cm
The Trustees of The British
Museum
(1922,0410.142.20) Fig. 41

Published to accompany the exhibition
Visions of Paradise
The National Gallery, London
4 November 2015–14 February 2016

This catalogue has been generously supported by
Howard and Roberta Ahmanson.

The exhibition has been supported by
Howard and Roberta Ahmanson
Moretti Fine Art Ltd.
The Rothschild Foundation
The Vaseppi Trust
and several other donors.

The Sunley Room exhibition programme is supported by
the Bernard Sunley Charitable Foundation.

This exhibition has been made possible by the provision of insurance through the
Government Indemnity Scheme. The National Gallery would like to thank HM
Government for providing Government Indemnity and the Department for Culture,
Media and Sport and Arts Council England for arranging the indemnity.

This edition published in Great Britain in 2015 by
National Gallery Company Limited
St Vincent House
30 Orange Street
London WC2H 7HH
www.nationalgallery.co.uk

ISBN: 9781857095944
1040416

British Library Cataloguing-in-Publication Data. A catalogue record is available from
the British Library.
Library of Congress Control Number: 2015947393

Publisher Jan Green
Project Editor Rachel Giles
Editor Emily Winter
Picture Researcher Suzanne Bosman
Production Jane Hyne and Penny Le Tissier
Designed by Adrian Hunt

Origination by DL Imaging, London
Printed in Italy by Verona Libri

All measurements give height before width

(Front, back, and inside front and back cover):
FRANCESCO BOTTICINI
Details from *The Assumption of the Virgin*,
1475–7
Tempera on wood, 228.6 × 377.2 cm
The National Gallery, London